THE ESSENTIALS OF
DRAWING

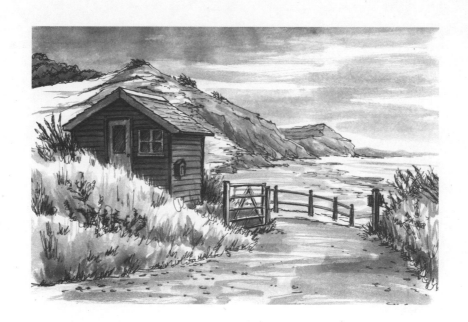

THE ESSENTIALS OF
DRAWING

SKILLS AND TECHNIQUES FOR EVERY ARTIST

PETER GRAY

ARCTURUS

ARCTURUS

This edition published in 2013 by Arcturus Publishing Limited
26/27 Bickels Yard, 151–153 Bermondsey Street,
London SE1 3HA

ISBN: 978-1-84858-618-5
AD002178EN

Printed in China

Contents

Part: I Essential skills and techniques...6

Looking and seeing.................................8

Materials...10

Mass, shape, form and detail11

The basic drawing process12

Multiple masses14

The page ...16

Measuring proportions18

Measuring angles21

The human figure22

The human head25

Feeling for form28

Receding angles30

Perspective theory.................................32

Perspective in practice36

Shapes in perspective.............................38

Three-point perspective40

Variations of line42

Introducing texture44

Light and shade....................................46

Shading and hatching..............................48

Charcoal ...50

Aerial perspective.................................52

Transparent media.................................54

Sketching with wash...............................56

Brush drawing58

Tonal brush drawing60

Marker pens62

Opaque media.....................................64

Part II: Seeking essential truths66

Framing and selection..............................68

Composition..70

Restricted tone.....................................72

Continuous line....................................74

Blunt instruments..................................76

Working at different scales.........................78

Time limitations80

Sketching ..82

Simple form86

Elegance...88

Symmetry..90

Geometry and structure92

Bright light...94

Dramatic light......................................96

Rear lighting 100

Flat light .. 102

Atmosphere....................................... 104

Spatial depth 106

Surface ... 108

Real life .. 112

A complex scene.................................. 114

Wear and tear 116

Personality 120

Whimsy ... 124

Narrative ... 126

Index.. 128

PART I: *Essential skills and techniques*

Many people have doubts about their ability to draw, but the very fact that you're reading this book suggests that you possess the most essential quality for learning how to do it – the willingness to give it a go. It's surprising how many people say flatly that they cannot draw and are so convinced of this that they don't think it's worth attempting to develop some skill.

To say this book is suitable for beginners is only partially true, because in drawing there is in fact no such thing as a beginner. Every child feels the compulsion to draw and does so with a confidence we can only marvel at in adulthood. That confidence to set down marks on paper with boldness is one of the greatest assets an artist can attain, and this book aims to bring it out in readers of all abilities.

While all the traditional subject areas are covered – still life, landscape, architecture and interiors, human and animal form and portraiture – they don't feature as individual blocks of study. Instead, the course charted here is through the processes of drawing, starting from the most basic of techniques and taking on new subjects as stepping-stones towards developing a sophisticated style of working.

However, sophistication shouldn't be understood here as complicated and time-consuming. The main aim of this book is to instil in its readers that there's much more, and very much less, to drawing than reproducing photographic reality. The desire for realism is the greatest barrier to beginners taking up the practice and the reason why they often become disenchanted once they've started. Instead, we shall focus on simplicity. A work of simplicity is a work of sophistication. Any fool can make things complicated, but it takes effort to stick to clear intentions and to know when to stop fiddling.

After making your way through the first part of this book you will have acquired a grounding in all the basic essentials of drawing theory: proportion, perspective, light and shade, mark-making, and so on. You will have experience of a broad enough range of subjects and techniques to identify the areas of study that most appeal to you and will be on your way to establishing your own style of drawing. Then you will be ready to progress to part two and begin making positive artistic statements with confidence and simplicity.

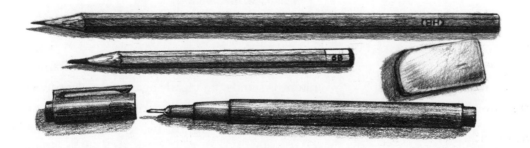

LOOKING AND SEEING

We look at objects all day long, but in our busy lives we do it merely to identify them. For example, you look into a kitchen cupboard, select a glass, fill it with water and casually drink from it. You probably never take the time to consider the woodgrain on the cupboard door, the industrial contours of the tap, the sparkling reflections on the glass, or the mysterious, distorted, upside-down world visible through the water.

A good drawing doesn't come out of mere glimpses of a subject, but of a period of time spent studying it, analyzing it and relearning what you know about it, accepting that things do not necessarily look the way you have always thought they do. By learning not merely to look but to really see, you will enter a new relationship with the world around you – one of immersion, engagement and, often, wonder.

The first drawing is clearly a cushion shape: the outline pulls in correctly at the sides, it has a bit of shading to suggest its bulk and even some neat piping running around the edge.

The next version is more typical of the cushions we come across in real life (at least in my house), squashed, wrinkled and set at an angle to the viewer. We rarely see objects in pristine condition from face-on viewpoints – and they are in any case less interesting to draw.

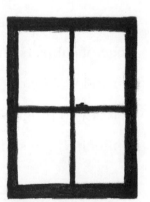

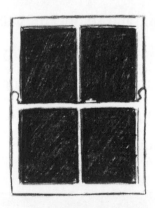

It would be difficult to convince anyone that these lines are horizontal. They are clearly set at steep angles, but that is how you would have to draw them for a convincing impression of a matchbox standing on a level surface.

Here are two drawings of a white window frame. At night its whiteness stands out clearly against the darkness outside, but during the day the brightness of the sky changes our view of it entirely, making it appear black. Given such a changeable visual world, we have to reappraise a subject with every new drawing and expect the unexpected.

It doesn't take a seasoned artist to identify this as a young girl, but recognizing a subject and drawing it are two different things. Let's consider some of the many kinds of error of perception a novice artist might make when drawing a subject such as this.

To most people, the main feature would be the face, in which we recognize all the character and expression of the individual. But have you noticed how small it is? By my calculations, it's less than 5 per cent of the drawing's surface area. In this profile view, the features of the face are at the very front edge of the head, and only occupy the lower half of that.

Now look at how very broad the head is, not the egg-shape you may have in your mind but, from a side view, quite round – much wider than most beginners would allow in their drawings. Note too how far back the ear sits.

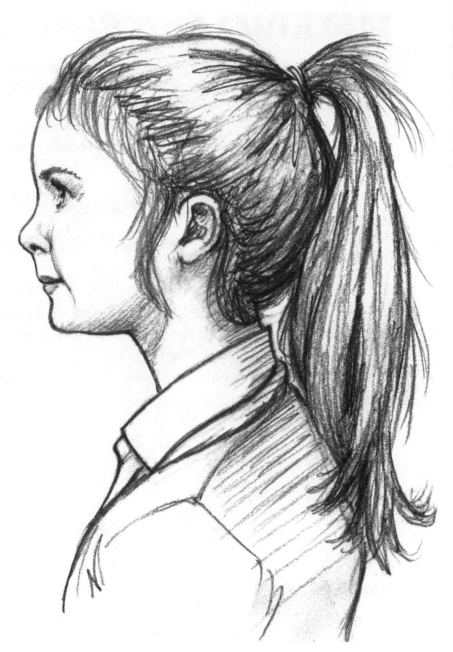

See also how the neck slopes forward – not upright, as many assume – and how long it is, within and above the collar. That collar, which we know to be round, here looks like little more than a flat rectangle. The hair, at first glance neatly tied back, is not actually so neat; the hairline is surrounded by wispy strands, which are really quite long by the ear, and odd tufts stick out of the hairband. Notice the bulge of the forehead, the heart-shaped lips, the triangular eye – and so the list goes on.

Seeing and judging things clearly and truthfully is a big first step towards being an artist. Now all you have to do is learn how to reproduce them on paper!

MATERIALS

It's very easy to be seduced by the array of materials available in an art shop, but bear in mind that Leonardo produced masterpieces of draughtsmanship with little more than a crayon. For most of the exercises in the book you will need only a very basic kit. In fact, cheap, basic materials are the best ones to use at this stage; expensive ones can make you hesitant and then your drawings will be stilted.

PENCIL

Most artists use soft pencils, which make lovely dense black marks. They are labelled in grades from B to 6B (very black). Hard pencils (H–6H) are of less use to the artist, but can be handy for making light guidelines. HB is the grade of a standard office pencil, neither very soft nor hard. Two or three pencils will suffice to start with: H or HB, B or 2B, and a 4B or 6B.

Sharpening

A pencil sharpener, especially one with a reservoir for the shavings, is a handy gadget to carry around with you on sketching trips. However, for best results, use a sharp blade or penknife to whittle your pencils to a point, exposing a good length of lead.

ERASER

An eraser is essential. In the course of a drawing you may wish to remove or soften mistakes, smudges and guidelines or you may change your mind about how the drawing should go and erase whole areas. You can also draw highlights with your eraser. All of this work is useful to your artistic development, since you learn from your mistakes.

PEN

The use of ink brings different qualities to a drawing and the act of making it. There are many types of ink, pen or brush available, but for early dabblings an artist's felt-tip drawing pen will suffice. Choose a 0.5mm nib for a good all-round size, or you could go for a couple, for example 0.3mm and 0.8mm.

PAPER

As you develop you may like to use better-quality papers, but to start with I recommend that you use any cheap white paper, perhaps in a sketchbook or as loose sheets with a drawing board to lean on. A3 is a good size (42 × 30cm/16½ × 12in), but A4 (30 × 21cm/12 × 8¼in) will suffice for most of the demonstrations in this book.

MASS, SHAPE, FORM AND DETAIL

Before you start to do any drawing, it's useful to acquire an understanding of some basic drawing terms and principles. The following examples represent some of the different aspects of a object you will need to consider in the process of drawing.

MASS

At the most basic level, objects you are going to draw can be thought of as just masses – shapeless blocks of certain sizes. It's worth spending a moment on the idea of masses because they are the foundations upon which most drawings are built.

SHAPE

Within the masses are shapes, which we can think of as the basic overall outlines of individual objects.

FORM

The subtler refinement of shapes is known to artists as 'form', by which we may mean an object's sense of solidity, internal construction, and so on.

DETAIL

Yet another step of refinement concerns the detail – the surface markings, patterns and textures of an object.

THE BASIC DRAWING PROCESS

Most drawings follow the same basic process, essentially working from large to small – that is to say, starting with the mass or masses of a subject and working towards smaller details. Along the way, guidelines are generated to help break the subject down into manageable and logical chunks.

Simple though it is, this rudimentary oval immediately establishes the general mass of the subject, its height relative to its width and its general shape. This stage took no more than a second or two to draw.

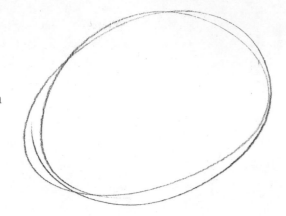

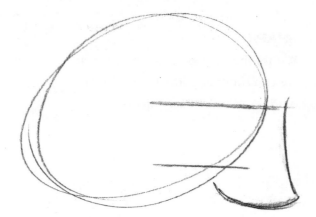

Next, I quickly marked the secondary mass – the projecting face area and rough lines for the brow and cheekbone.

Embarking on the network of guidelines, it was now quite easy to place the main shapes and features that make this drawing recognizable as a skull.

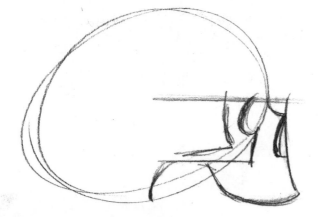

ARTIST'S ADVICE

Using a harder pencil or drawing lightly for underdrawings and guidelines makes the marks easier to erase. Here, I have drawn quite heavily with a soft pencil for the sake of clarity.

Next I tweaked the original oval to follow the subtler outline of the real object, which is rather more angular than it may first appear.

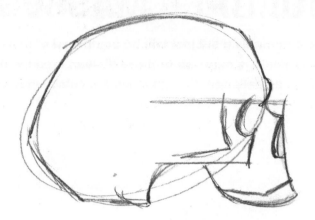

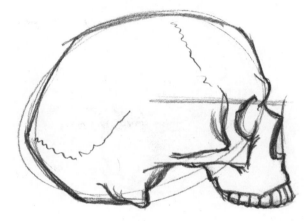

With most of the detail in place it was now a case of refining and defining the outlines, using more pressure on the pencil or switching to a softer, blacker one.

At the final stage, I carefully erased all the guidelines, dirty marks and mistakes. Adding a few strokes of shading helped to clarify the form of the skull.

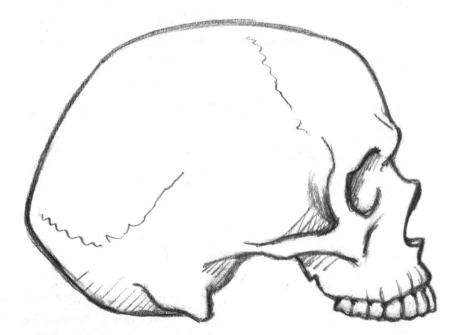

ARTIST'S ADVICE

To erase marks around small details, use the corner of an eraser, which can be reshaped with a knife when it wears blunt.

MULTIPLE MASSES

More commonly a subject will be composed of more than one basic mass. This example is made up of three distinct areas, but it need not present too much of a challenge if the masses are established clearly from the beginning.

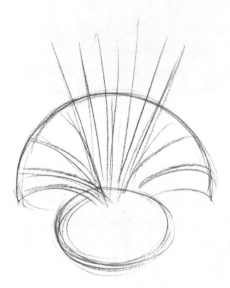

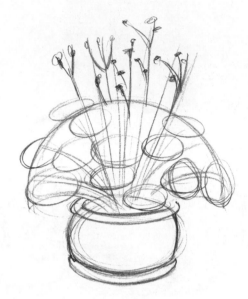

Ignoring any detail, I simply marked the broad shapes to position them and their relative sizes on the paper. I have also indicated the general thrust of the plant's growth emerging from the pot, the ends of which mark the overall height of the upper mass.

Next I looked at the smaller shapes within the masses, marking the rough sizes and positions of the larger leaves as well as the individual flower stems and their end points. I added a little shape, or form, to the pot. This very simple network of pencil guidelines is all that's needed to be able to add detail with confidence.

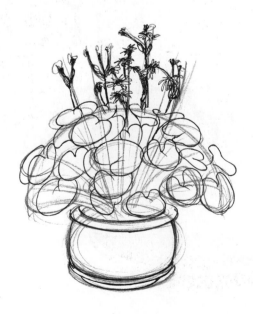

In this case I decided to continue in ink, using a fine felt-tipped drawing pen, but you can equally well use pencil. First I drew the large foreground leaves, looking at them carefully to capture their individual shapes and sizes. Then I worked on the partially obscured leaves and added the main flower stems, again referring closely to the subject and veering away from the guidelines where necessary.

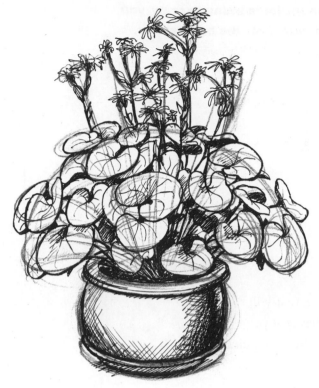

With the main leaves in place, it was easy to draw the other leaves and stems in the spaces in between. After completing the flowers and the pot, I added some rough shading to give the drawing solidity and depth. (This is covered in more detail on p.48–49.)

15

Here you can see why I used ink for the final drawing. As it is a stable medium that cannot be rubbed out or smudged once it is dry, all guidelines can be erased quickly in broad strokes of an eraser, leaving a clean drawing without the need for any fiddly erasing.

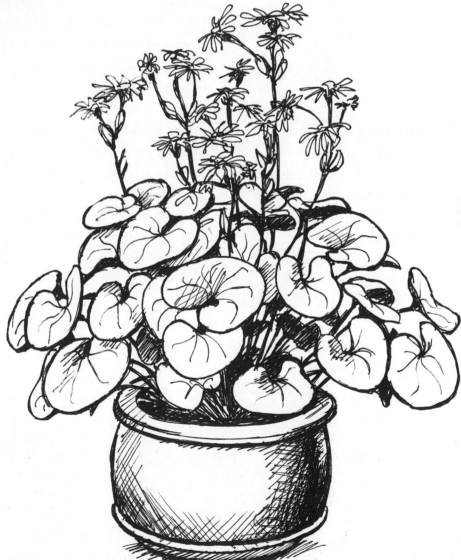

THE PAGE

Though the type and quality of paper is not very important for learning to draw, you must still consider how your sheet of paper can be employed for the best results.

FORMAT

Before drawing anything, turn your paper around to the appropriate format for the subject. Working with the paper laid out horizontally will produce a drawing in what is known as 'landscape format'; vertically, the drawing will be 'portrait format'.

SIZE

Try to work at a decent size that will allow you space to draw freely; if you start off too small the drawing will quickly become stilted and difficult to develop. Your under-drawings should fill a good portion of the paper.

However, if your intention is to make very quick studies, it may be wise to avoid making them too large and unwieldy. Working several to a page saves time and keeps your pencil flowing.

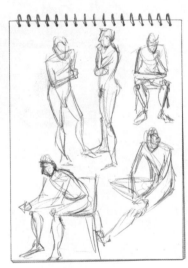

FILLING THE PAGE

I did this little sketch in an A6 sketchbook (14 × 10cm/5¾ × 4in). I made a conscious decision to let the plants fill the whole page, cropped off by the paper's edges. This makes for a sense of liveliness.

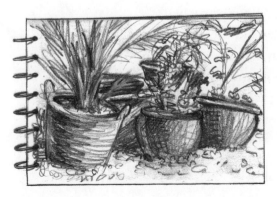

GOING OFF THE PAGE

During the process of drawing, some elements often end up without sufficient room on the page. Rather than squashing things up to make them fit the paper, it's far better to draw them to proportion and accept that they will run off the page.

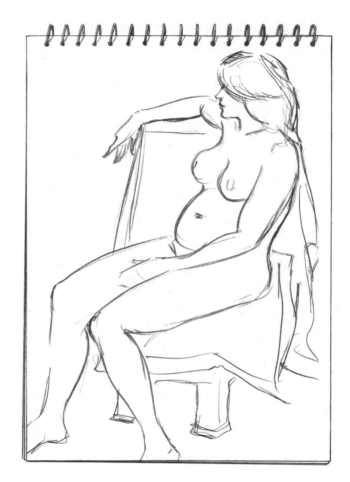

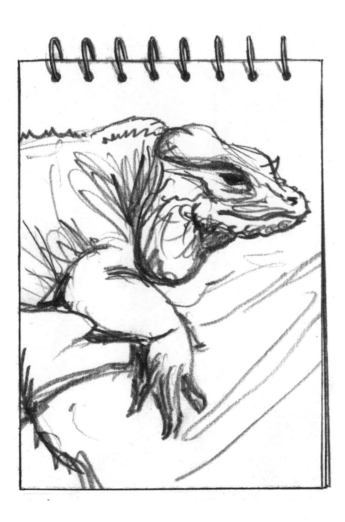

SELECTED DETAIL

You may choose not to draw a subject in its entirety but to select the parts that interest you most.

SKETCHBOOKS

Working in sketchbooks is a good way to keep your drawings together and in order. A spiral-bound A4 book is a good-all round size but is rather large for general portability. Drawing away from home provides excellent practice, so I recommend that you also buy a smaller sketchbook to carry in your bag or pocket for whenever the opportunity arises for a quick sketch. Many of the pictures in this book are impromptu sketches in pocket sketchbooks.

MEASURING PROPORTIONS

This subject, a sculptural detail from a fountain, is rather more complex than those on the previous pages. Though it can easily be thought of as a series of masses and shapes, it may be best approached in a different way. The following demonstration involves a technique known as sight-sizing that's used by many artists. Note that the scale of your subjects and your drawings won't always comply with the convenient measurements of a pencil; it may be necessary to measure and mark off in fractions or multiples of pencil lengths.

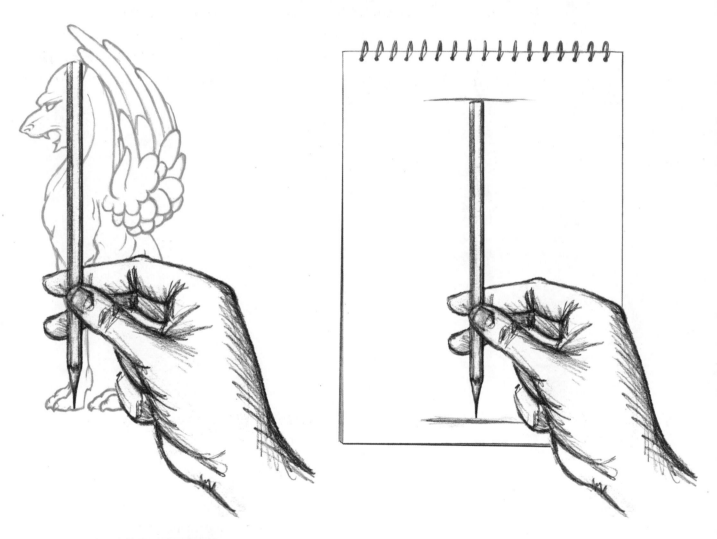

SIGHT-SIZING

Imagine you're standing at a distance from this statue and holding out your pencil with your arm fully extended and elbow locked straight. This gives you a stable measure of relative distances. Let's say that from your standing point, the statue appears to be the same height as your pencil. You can then mark on your paper the upper and lower extents of a drawing, with one pencil length in between, in this case making sure to leave space above for the wing tip.

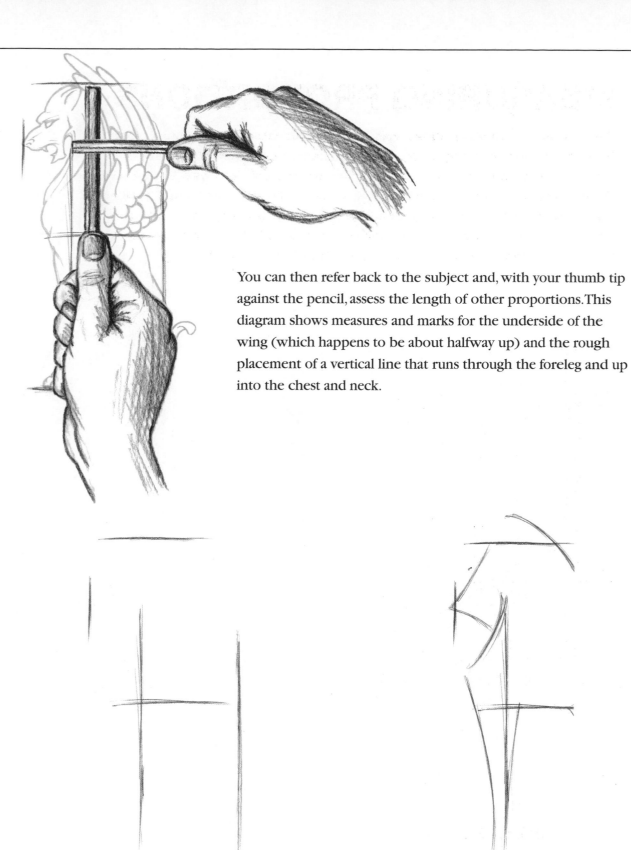

You can then refer back to the subject and, with your thumb tip against the pencil, assess the length of other proportions. This diagram shows measures and marks for the underside of the wing (which happens to be about halfway up) and the rough placement of a vertical line that runs through the foreleg and up into the chest and neck.

With the overall height, width, and a couple of internal measurements, I made a kind of grid, into which an accurately proportioned drawing should fit quite easily

Within the grid it was now easy to mark the curves that make up the main masses of the statue with some accuracy, using the sight-sizing method to check any more proportions I was unsure of.

It didn't take long to construct a more or less complete outline over the guidelines, since this consisted of little more than a joining up of the various parts of the guideline framework.

With all the hard work done a more precise outline fell into place quite quickly, with the details worked up within the established shapes.

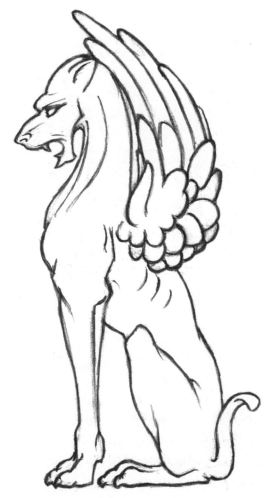

With the guidelines erased and the fuzzy outlines cleaned up, the result is quite a bold and sturdy-looking figure.

MEASURING ANGLES

Equally important as the proportions of the shapes and lines of a drawing are its angles. Nearly all drawings will involve assessing and setting down angles in some way or another. Once again, the pencil comes to the rescue as a very quick and effective aid to judging and copying the angles that make up any subject.

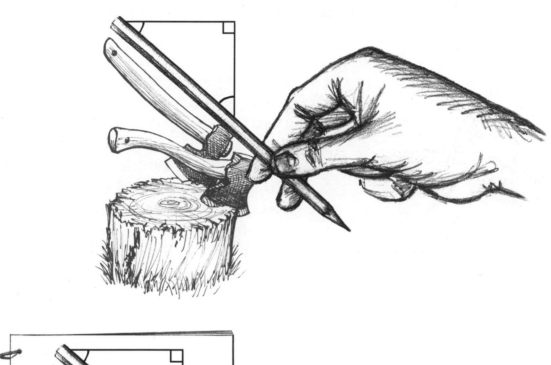

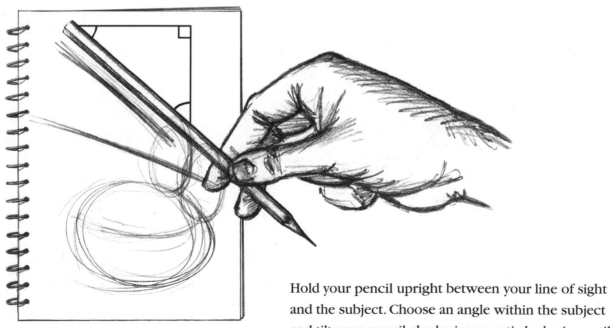

Hold your pencil upright between your line of sight and the subject. Choose an angle within the subject and tilt your pencil clockwise or anti-clockwise until it matches. Then, without changing its angle of tilt, simply move the pencil down to your paper and mark it on your drawing. Once you have a few strong angles marked down, even quite complicated drawings will fall into place relatively easily.

THE HUMAN FIGURE

The human body, or figure, is one of the great traditional subjects of drawing, and one that provides fascinating challenges for even the most seasoned of draughtspeople. It can be a subject of great sophistication, but the techniques we have covered so far will be sufficient to make a good start. This demonstration will involve mass, shape, form, proportions and angles, and will also introduce the ideas of balance and thrust.

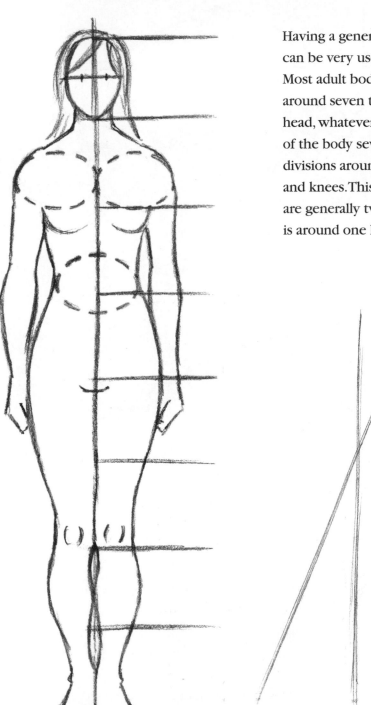

Having a general idea of the proportions of the figure can be very useful, especially for standing poses. Most adult bodies, male or female, short or tall, are around seven to eight heads tall. This means that the head, whatever its size, will fit into the total height of the body seven or eight times, making convenient divisions around the levels of the chest, waist, hips and knees. This diagram also shows that the shoulders are generally two head lengths wide and a trim waist is around one head length wide.

In any standing figure there will always be one or more tensions that govern the balance and actions of the body. These can be captured as straight or curved guidelines that provide useful aids to drawing. In the pose opposite and on p.24, the line of balance is quite clear to perceive, running up through the leg and the upright torso. It also has a thrust to the right, a line of action that runs at an angle through the left leg up towards the outstretched arm. The pencil can be used to assess the angle of this action line and mark it on the paper.

Once I had marked the
upper and lower extents
of the figure, it was easy to
divide and subdivide the
height to provide rough
pointers for drawing the
whole body.

Next I quickly roughed
in the main masses and
shapes that make up the
body: the head, torso, hips
and legs.

Using the pencil's length again
to assess the subtler angles of the
extremities, I marked the shoulder
line and the general thrust of each
arm. Also important were the
forward tilt of the neck, the angle of
the face and the trailing foot.

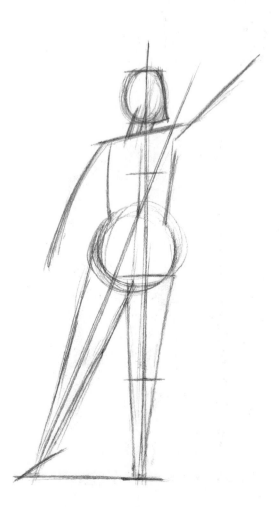

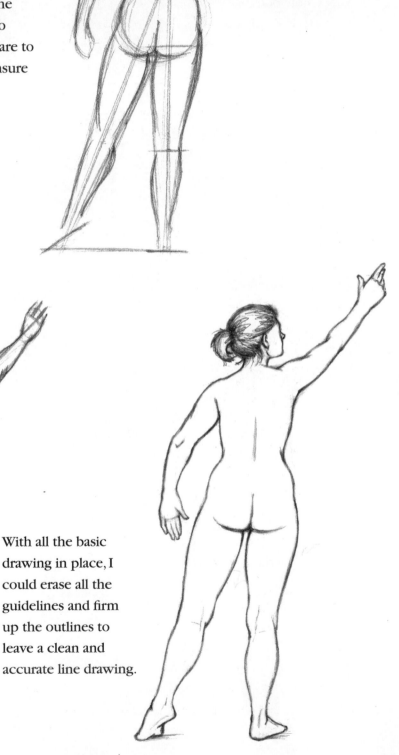

Next, with close attention to the model, I revised and developed the outline, making changes to the overall shapes if necessary. At this stage the broad and angular marks started to become sensuous curves. I took care to measure any proportions I was unsure of, such as the length of the arms.

From there on it was just a case of continuing to refine the drawing, always checking it closely against the model.

With all the basic drawing in place, I could erase all the guidelines and firm up the outlines to leave a clean and accurate line drawing.

THE HUMAN HEAD

The human head is another subject for which it may be useful to have a general idea of proportions. Although every head is different, they do follow a similar structure. The diagram below is not really to be thought of as the first stage of drawing but rather as a set of general proportions to keep in mind.

Adult human heads, male or female, can be thought of as upside-down egg shapes. A vertical centre line helps to place the features with a degree of symmetry, and another line bisects the head horizontally at about the halfway point. This 'eye line' may be divided into five equal lengths as a rough guide to the width and placement of the eyes. Halfway down the bottom half, another guideline marks the bottom extent of the nose and ears.

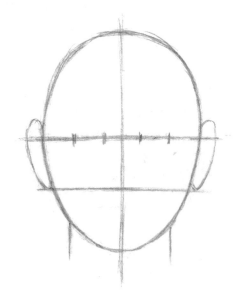

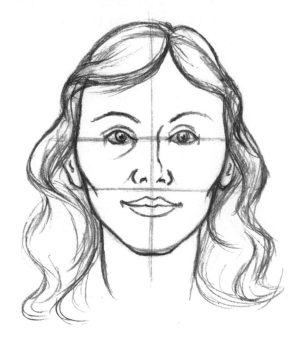

Of course real faces are much more interesting than any diagrammatic generalization. Through careful observation of a subject and perhaps some sight-size measuring, you will see where your subjects subtly diverge from the standard.

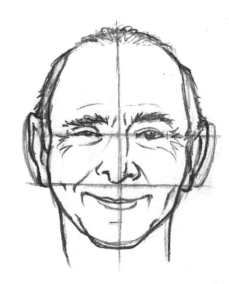

This face is male and much older, yet the features fit generally into the same template. However, on closer inspection we see that the head is narrower, the nose longer and so on. This face is also not very symmetrical, as the centre line helps to show. Such slight divergences from the template are very important in capturing likenesses.

THREE-QUARTER VIEWS

Most of the subjects so far have been drawn from simple front or side views. Drawing from more complex angles of view demands that we think of the subjects in more of a three-dimensional way.

This head is turned so that we can see both the front and side, which is to say a three-quarter view. As before, I began with the mass – here a rough oval. For this angle of view it's helpful to mark the vertical centre line to help in placing the features on either side of the face. Note that the line follows the curve of the head. The eye line remains straight.

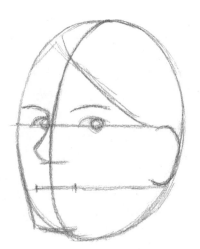

Next I roughly placed the main features. Faces are full of interesting contours, so when you draw them think of the centre line as a very rough guide and be led by observation of the subject. For example, this woman's eyes are quite deepset, so they sit some way back from the front of the face.

With the detail worked up it's clear that the lower face sits in front of the centre line and the face is somewhat slimmer than the original oval guideline. The face should look symmetrically balanced at this stage – if it doesn't, erase any dubious parts and redraw them.

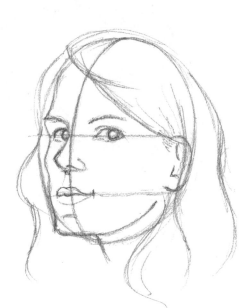

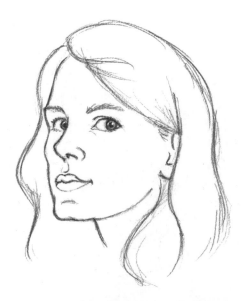

Finally, I erased the guidelines and refined the features, keeping everything simple and clean by using as few lines as possible. The hair is drawn as a general shape with just a few indications of texture.

A HIGHER VIEWPOINT

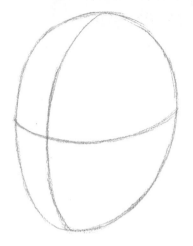

With high or low viewpoints lateral guidelines become more important in order to help place features at the appropriate height. Looking down on this head, I've drawn the mass and vertical centre line and also a curving eye line that wraps around the mass below the halfway level.

I drew the head following the same principles as before, but with extra attention to the levels of the features. It's easy to assume that you have a good sense of a familiar subject but careful observation may throw up some surprises. From this angle of view, for example, some elements almost overlap, such as the brows covering the tops of the eyes. Extending the line of the mouth will help in finding the level of the ear.

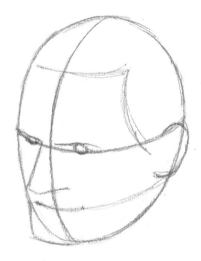

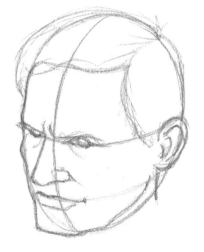

Once the features are refined and the outlines of the face are set down, the drawing develops into a believable solid form.

With the guidelines erased, a few wrinkles and contour lines can be added to lend the head character. The main thing to aim for is convincing heads that work three-dimensionally. Don't worry if you don't achieve perfect likenesses at this stage; they will come with time and practice.

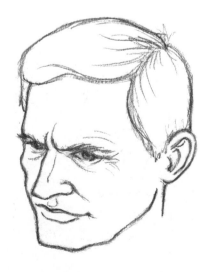

FEELING FOR FORM

For some subjects or viewpoints you may prefer to draw in a more free-flowing, intuitive manner, with the minimum of measuring proportions or angles. Some of the best drawings come out of such an approach, which allows you to feel free and unrestricted. Let's look at this approach applied to a stuffed hippo in a museum.

28

A couple of quick sight-sizing measurements helped to establish the sizes of the main masses. Certain viewpoints can result in unexpected distortions of proportion, so it's usually worth a quick check. Here, for example, my measuring told me that the mass of the head was virtually the same size as that of the body.

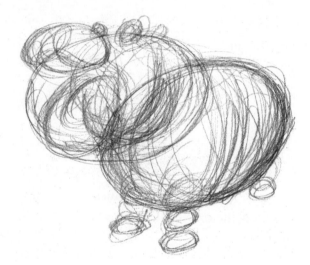

Working very freely in bold circular movements, I allowed my pencil to wrap around the various masses that make up the subject, adding knees and feet, jaws and lips, eyes and ears, making nothing too definite. Already the drawing has a sense of solid form that would take much longer to produce with a more cautious approach.

Somewhere inside the myriad lines the subject was lurking. The task at this stage was to develop the good lines and define the shape. I switched to a softer pencil so that the new lines stood out clearly.

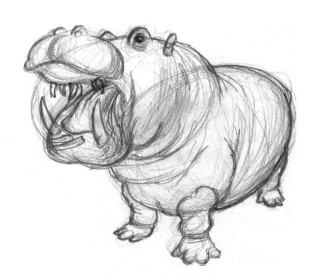

Where the swirling marks had given the drawing a solid three-dimensional feel it seemed a shame to lose them, so I used the eraser selectively to clean up around the edges and erase those marks that crossed over awkwardly, leaving those that follow the curving form of the hippo.

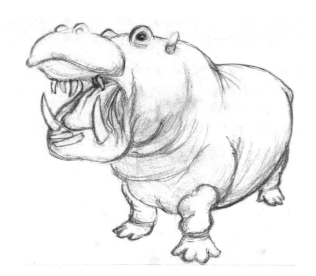

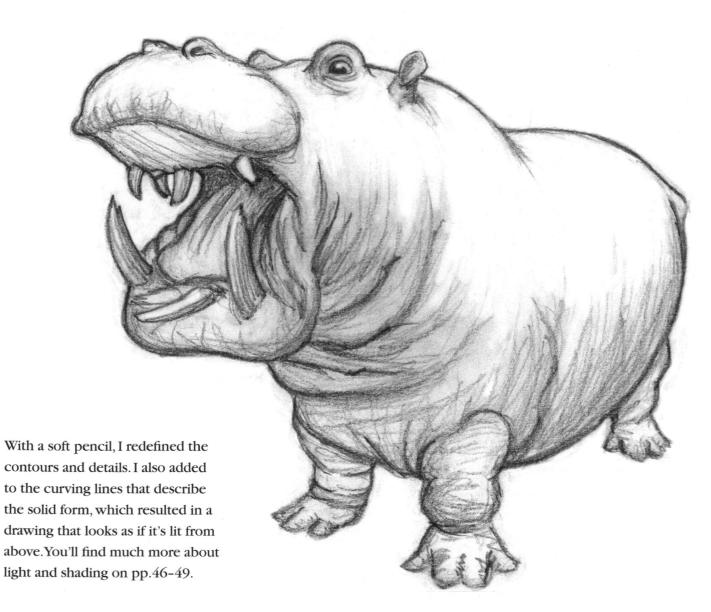

With a soft pencil, I redefined the contours and details. I also added to the curving lines that describe the solid form, which resulted in a drawing that looks as if it's lit from above. You'll find much more about light and shading on pp.46–49.

RECEDING ANGLES

You can't get very far in drawing solid objects before you need to consider the angles at which lines recede from view. This is the basis of what artists know as perspective drawing. Perspective can seem quite daunting, but in essence it's quite simple to show by means of a few devices that help us to make sense of a three-dimensional view so that we may draw it on a two-dimensional surface.

This drawing started with a very quick assessment of the proportions of the group and the masses within it, sketched in lightly. I used the pencil to check a rough measurement or two.

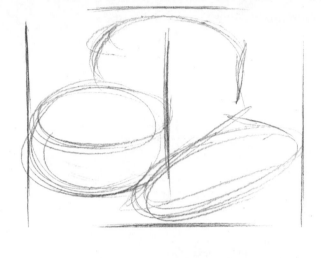

Next, in order for the various blocks of this subject to look as if they sit convincingly on a surface, some fairly accurate assessment of the angles was required. Again the pencil could help. When you try this for yourself, keep it in mind that it's essential that you do not tilt the pencil backwards or forwards – it should move in a single plane, left or right, as if placed against a sheet of glass. This mimics the flatness of the paper onto which you will transfer the angle.

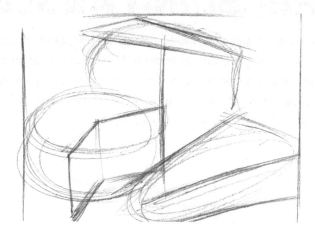

Assessing, drawing and rechecking with the pencil, I soon had all the main angles drawn onto the masses.

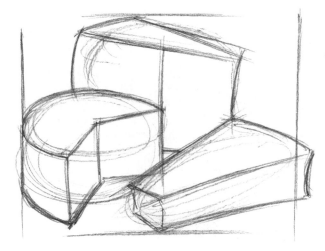

With a little more observation and some checking of proportions, the main shapes of the cheeses were quite easy to draw around the angles already established. Here we have solid objects existing in three-dimensional space transferred, quite painlessly, to the two-dimensional page.

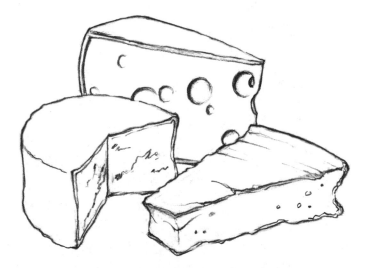

After erasing guidelines and errant marks, it's a pleasure to refine the outlines and add details that give the objects their individual characters. Always look carefully at the subject and try to avoid making any assumptions about what a familiar item may look like.

ARTIST'S ADVICE

Precision in form and dimension isn't essential for convincing drawings – if you make one element longer, fatter or more wrinkled than the reality it won't usually show in the drawing. However, if the angles of recession are badly assessed, objects appear to tilt and the drawing may suffer badly.

PERSPECTIVE THEORY

Unlike randomly placed wedges of cheese, much of our world is ordered into parallel lines and right angles, which makes drawing them relatively easy when you have mastered the rules that govern their appearance. The concepts of perspective are quite simple to understand and incredibly helpful.

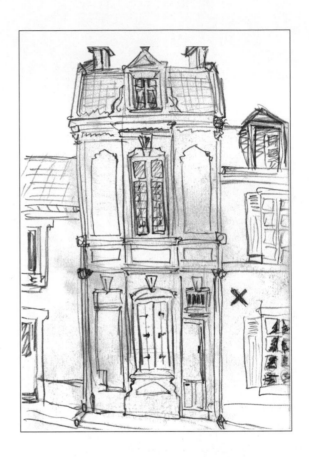

NO PERSPECTIVE

This quick sketch involves almost no formal perspective at all. Seen square on, an object presents a single face that requires little analysis to draw. All the main lines of construction are either vertical or horizontal.

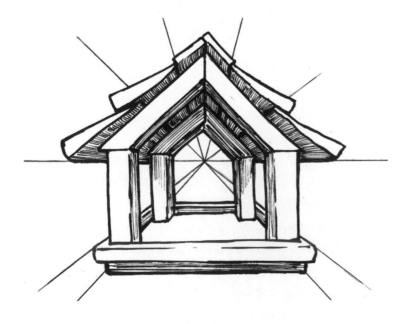

ONE-POINT PERSPECTIVE

From this angle of view, all the lines on the front-facing planes of my bird table remain vertical, horizontal, or at the 45-degree roof angle. But as we look beyond the front plane, into the interior, we can see the lines that run into the distance, which are at very different angles to each other. However, they can be seen to converge at a single point in the distance – the 'vanishing point'.

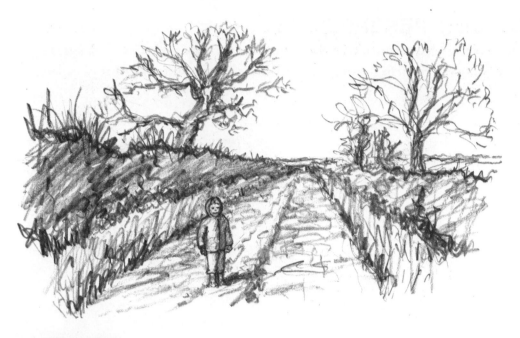

THE HORIZON

The landscape in this sketch is very flat, which means that the horizon is absolutely on the level with my eye line. You can see that the hedges to the left were slightly taller than me, and those on the right were slightly shorter. Likewise, the trees and the child take their natural height relative to my eye line.

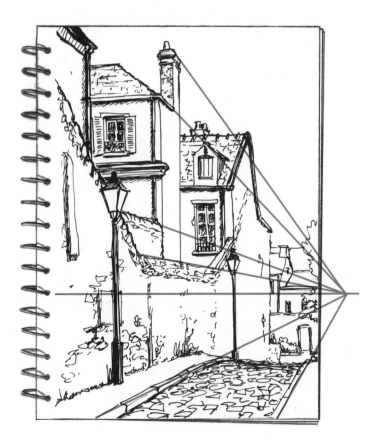

THE VANISHING POINT

The vanishing point is to be found on the horizon, directly in front of my line of sight. By taking a vertical line down from the vanishing point, you can tell that I was standing on the right-hand side of the lane.

The vanishing point won't always be in the picture. In this sketch you can see that the receding lines converge at a point off the edge of the page. This makes the view seem less formal. I didn't mark any strict perspective guidelines to do this drawing but kept the approximate placement of the vanishing point very much in mind as I assessed the receding lines with the out-held pen.

TWO-POINT PERSPECTIVE

Looking at things from more of a three-quarter view means that both surfaces recede into the distance, requiring a second vanishing point, or 'two-point perspective'.

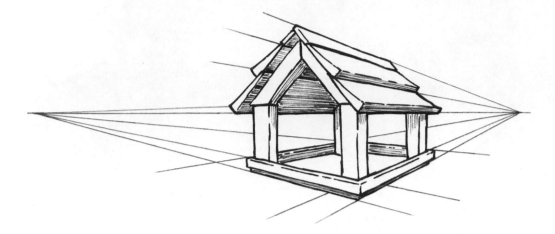

For this diagram, I stepped to my right, exposing the side as well as the front of the bird table. Thus my original vanishing point also moves to the right, further along the horizon, and way over to the left another vanishing point helps us to comprehend the recession of the front plane. Yet all vertical lines remain strictly vertical.

With this warehouse I employed two-point perspective in quite a loose way. After mapping out the main masses, I observed my eye line and marked it as a horizontal line. Then I assessed a sampling of the receding angles with my out-held pencil and roughly marked them on the drawing.

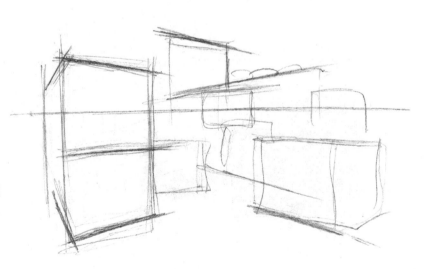

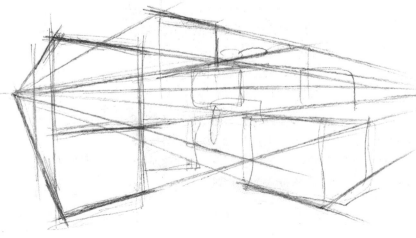

I extended the initial sampling of angles to form a kind of rough grid over the drawing. I did this all freehand, without rulers and without a clear location for the right-hand vanishing point, far off the edge of the page.

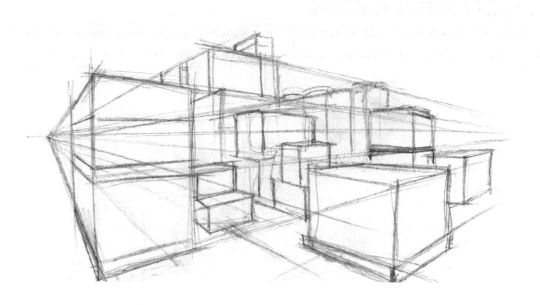

In the crudely constructed grid, I could then mark out the clear shapes of the various bundles and boxes in the warehouse.

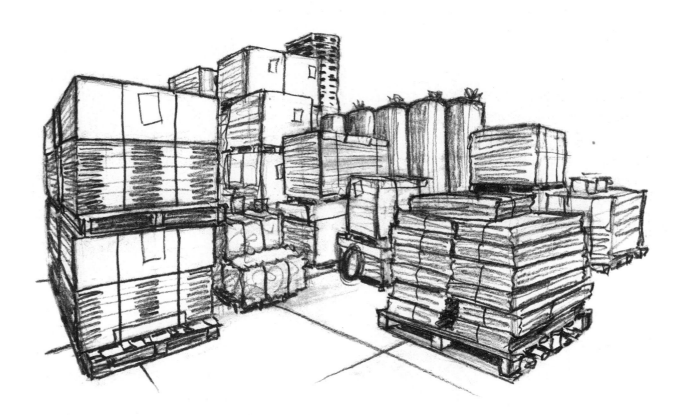

After erasing the rough lines of the perspective grid, I switched to a softer pencil. With all the real drawing done, I merely had to sharpen up the outlines and add a little detail here and there.

PERSPECTIVE IN PRACTICE

For this sketch I stood quite close to the buildings, which placed my main vanishing point (on the left) very close to the edge of the buildings. The result is very steep lines of perspective and a feeling of involvement in the scene.

The buildings here were further away from me so my view was more oblique. This placed the main vanishing point (the right) a long way over, resulting in shallower angles of perspective and a more detached feeling. With the vanishing point so far off the page it would be folly to struggle with a precise perspective grid, so I judged all the angles by eye. As long as you maintain a degree of consistency across the drawing, perspective does allow some room for imprecision.

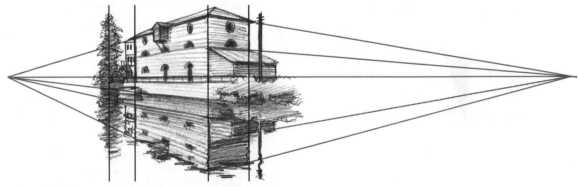

REFLECTIONS

To draw something reflected in water, all the vertical lines carry on downward to remain vertical in reflection and run to exactly the same vanishing points. It may help you to think of the subject and its reflection as a single mass.

CURVES

Not everything is composed of entirely straight lines and you'll soon come across the problem of drawing circles, arches and other curves in perspective. So let's draw an arch, starting with a simple perspective rectangle. To find the apex of the arch we need to find the centre line, which is done by marking a cross from corner to corner and then taking a vertical from the centre.

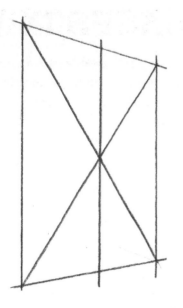

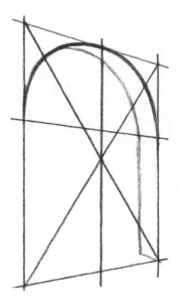

Mark the bottom extent of the curve and strike a line to the vanishing point so that the level tallies with the opposite side. Thus we have the two equal quadrants clearly marked and a smoothly flowing curve can be drawn within the guidelines. To show the thickness of the arch, draw another line inside that follows the contour of the outer edge.

Here we have arches within arches. It's a simple drawing, but it would have been very tricky without the theory of perspective curves. Note that the arches are constructed off different vanishing points, depending on their orientation.

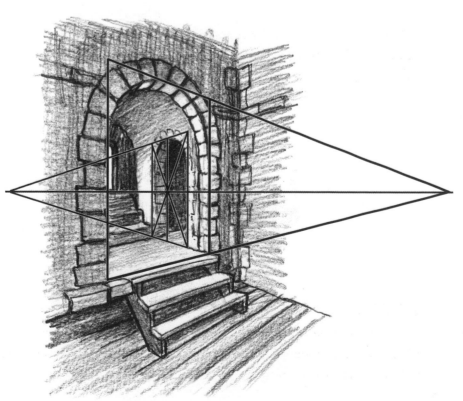

SHAPES IN PERSPECTIVE

Elementary perspective turns out to be useful for drawing all sorts of objects, not just the obviously geometrical ones. Here we explore the perspective box as a very useful device for getting to grips with the structure of all sorts of drawing challenges.

I did this tiny sketch with a ballpoint pen and no pencil guidelines. It wasn't especially difficult because the vehicle is essentially box-shaped. Once I had established the basic dimensions and angles, all the detail could then be fitted into the scheme.

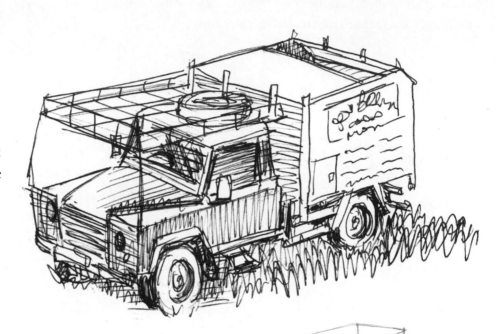

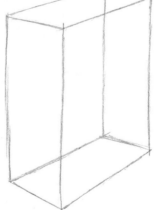

Construct a box following the rough proportions of the object you want to draw. With some quick angle assessment and common sense, you shouldn't find it necessary to draw vanishing points and receding lines.

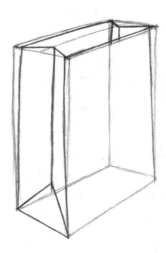

The box may now be tailored to suit the particular subject. This paper bag had sides that sloped in at the top, so I redrew the uprights to lean inwards. Another guideline dictates the centre line of the bag's opening, which helped me to draw the folding sides of the bag.

Now it was no longer necessary, I could erase the original box. To draw the handles, I then constructed another box, this one following the slopes of the bag. The box form allows the handles to be placed symmetrically on both sides of the bag, maintaining a uniform height.

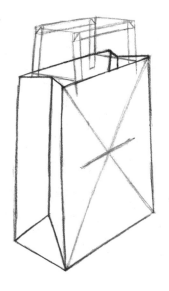

I could now draw the handles confidently. To find the centre of the bag, for a logo, I marked diagonal lines from each corner.

Finally, I erased all the guidelines. The end result was a strong, simple drawing.

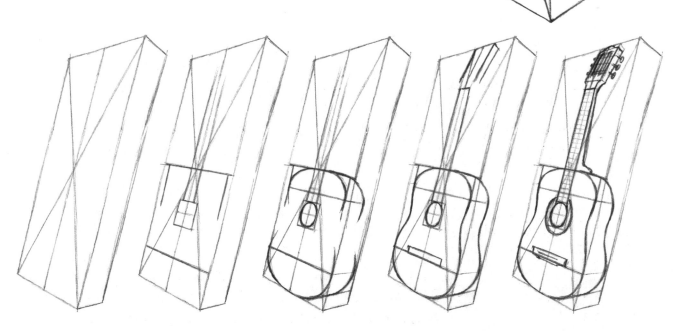

You'll soon find that you can draw all sorts of objects from different angles so long as you can draw the initial boxes in reasonably correct perspective and use the appropriate guidelines. This guitar, for example, needed a strong centre line on its front face and definite guidelines for the upper and lower curves of its body.

THREE-POINT PERSPECTIVE

Generally, two-point perspective is sufficient for most subjects and viewpoints, but there is a third point that comes into play when you're looking sharply up or down at a subject. It can be used to varying degrees and it's worth taking on board because it can be subtly effective or quite dramatic in use.

40

Returning to my bird table, I drew it from a lower viewpoint, effectively looking up at it. This means that the upper parts are further away and so the upright lines will naturally recede into the distance, meeting at a point high above. This diagram is rather exaggerated; the angles wouldn't normally be so steep unless seen from very close up.

In most cases, the presence of a third perspective point doesn't require much more than a general awareness of it as you draw. Horizontal lines of recession are usually far more evident, as demonstrated by this farmhouse. The vertical sloping is quite subtle, but it's quite important to the elegance and naturalism of the drawing.

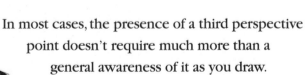

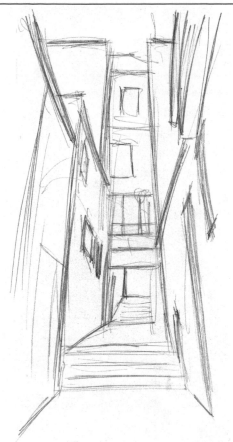

The overhead perspective point is more evident here, but the drawing was hardly more rigorous. As the initial guidelines show, all that was required was a few main guidelines roughly judged and marked and the rest of the angles fell into place in the drawing process.

Three-point perspective isn't restricted to things towering over our heads; it's more likely that you'll use it for looking down on smaller subjects. The closer to the subject you stand, the more exaggerated the angles will be.

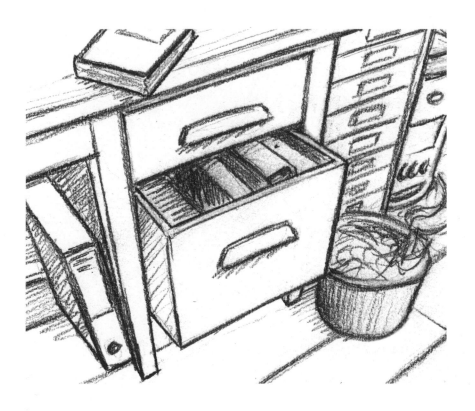

ARTIST'S ADVICE

Choosing subjects where the angles aren't precise, such as rickety old buildings, means you can take a very loose approach to perspective and any odd discrepancies will only add to the subject's charm. In such cases you can avoid too much concern with the technicalities of perspective and enjoy drawing freely.

VARIATIONS OF LINE

It won't have escaped your notice that the drawings shown so far have demonstrated some variation in the way that the lines have been formed. Now we'll look into this matter further as we delve into the area of mark-making. Your choice of pencils or pens inevitably affects the outcome of a drawing, but the marks you make will also depend very much on how you use your materials.

For this one-minute sketch I used a marker pen and concentrated only on setting down the angles and proportions of the figure. The heavy line lends solidity to the pose, but little sensitivity.

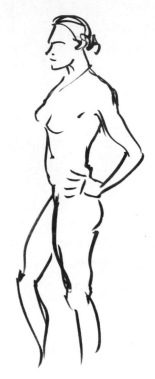

With the more sensitive medium of pencil, I aimed to capture a sense of the thrust and tensions within the pose. Again, I stuck to a one-minute time limit, which inspired me to use direct, unbroken and unfussy lines, lending dynamism to the figure.

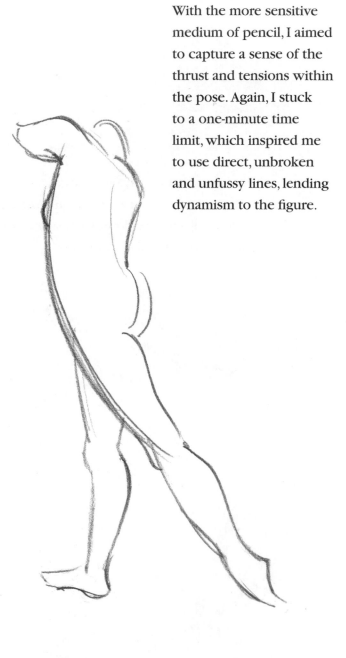

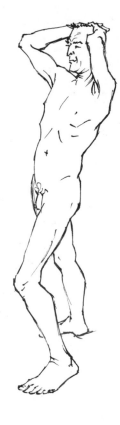

Shorter, scratchy strokes of the pen bring out the angular, knobbly qualities of the older physique. The pose still has a thrust to it, but the feeling is less graceful.

To sketch this old chair, I allowed the pencil to spiral around the curves and mouldings, aiming to replicate its dilapidated, baroque qualities.

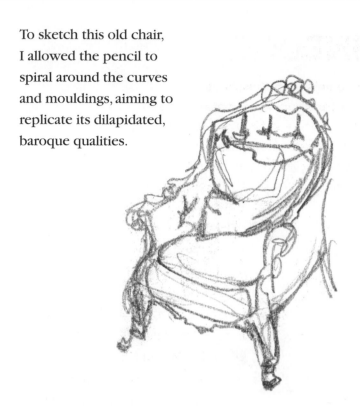

This chair is similarly old and wonky, but quite different in its structural feel. Here I sketched with firmer, straighter lines, contrasting with the curving lines of the rucksack hanging from it.

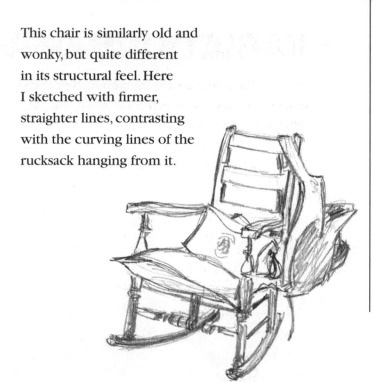

On a sketching trip to a regional museum, I set myself the challenge of drawing a number of sculptures, carvings and masks using a very different style of line for each one. I aimed to be sympathetic to the character and material of the subjects as well as tapping into the feel achieved by the craftsmen who made them. Such studies make excellent practice for identifying and developing your own artistic style.

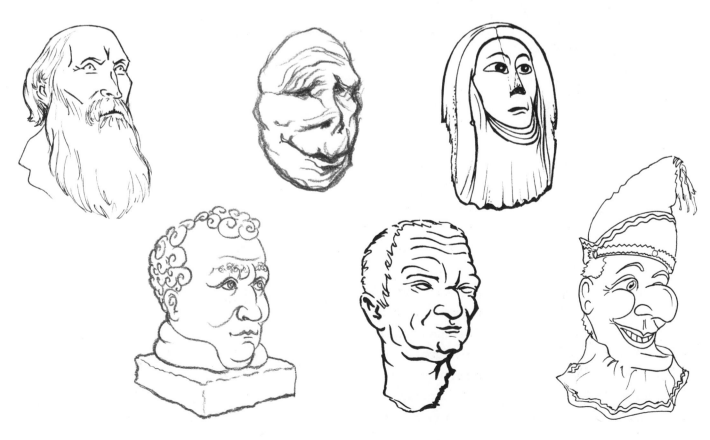

INTRODUCING TEXTURE

In drawing with a conscious approach to mark-making, we naturally start to imbue our subjects with a sense of the surface, or texture, of the materials from which they are composed.

44

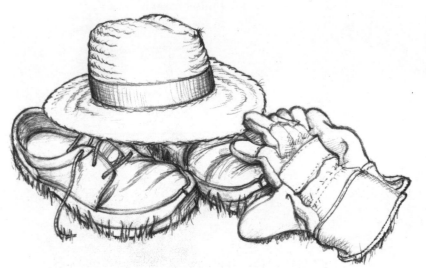

In this study I strove to show something of the particular textures of the various objects: the woven straw of the hat, the soft suede of the gloves and the rigid leather of the shoes. The outlines do most of the work, complemented by some minimal shading and detailing. The ground, although barely drawn at all, is clearly a grass lawn, indicated by the mere suggestions of its texture along the bottom edges.

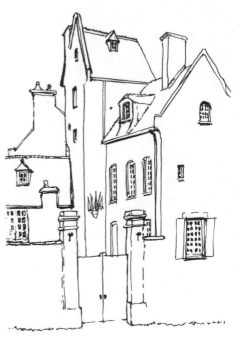

The shapes and angles of many subjects can be interesting enough in themselves to make worthwhile studies, but sometimes the addition of varied textural marks can enhance their character and charm. With the pencil guidelines erased, this pen study, despite its very solid subject matter, looks quite flat and lightweight.

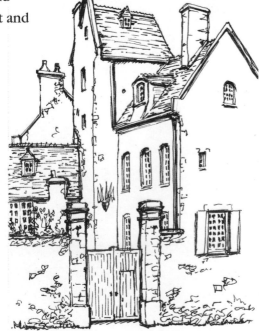

It doesn't take much in the way of texture on the walls to make the buildings appear more sturdy and ancient. Similarly, the tiled roofs now look heavier and the gate more formidable. Although the lines on the gates were clearly visible, I drew them with broken lines to avoid over-inking that part of the drawing. I then strengthened the outlines of the gateposts to bring them forward against the background.

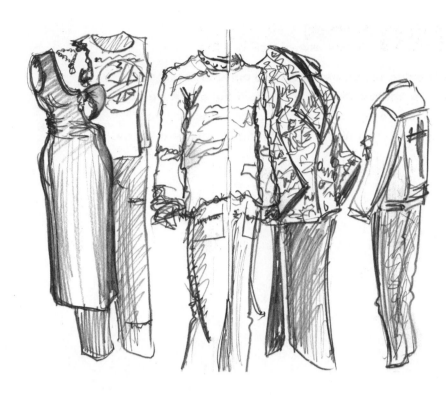

Textural drawing soon becomes instinctive. In a quick sketch, without really thinking about it, I used different outlines and pencil marks to convey fluffiness, wrinkles, stiffness and weight of cloth, surface pattern and so on. The differences between the surfaces can be quite sketchily hinted at where you can rely on the viewer's knowledge of the types of clothing depicted.

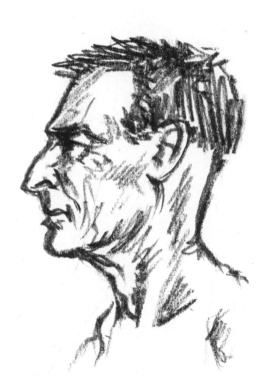

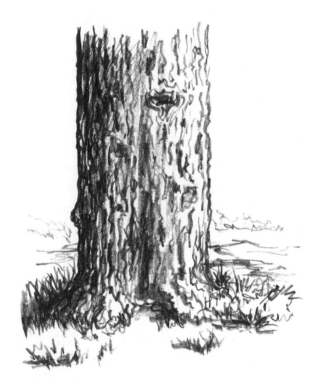

As I sought out the crags and wrinkles of this careworn face, the firm marks of a very soft pencil built up a solid and characterful portrait. I used different marks for the spikiness of the hair and went over the outside edges extra heavily to soften the character lines in comparison.

The ridged and pitted surface of its bark catches the light differently on each side of this tree, requiring heavier and lighter marks. Effectively, the textural treatment conveys the light and shade, giving the subject a rounded, three-dimensional look.

LIGHT AND SHADE

Just as mark-making leads to texture, so texture brings us on to tone. 'Tone' is the technical term for the range of lights and darks that make up a picture. It may refer to the inherent darkness or colour of an object, known as its 'local tone', but more usually it's used in relation to the description of light and shade.

46

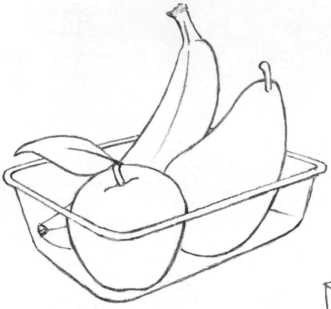

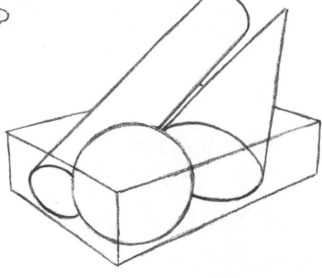

As we consider tone it may be helpful to recall Paul Cézanne's advice to see nature in terms of the cone, the cylinder and the sphere. He asserted that at a basic level any natural object can be broken down into these shapes, and the punnet of fruit offers some quite literal examples.

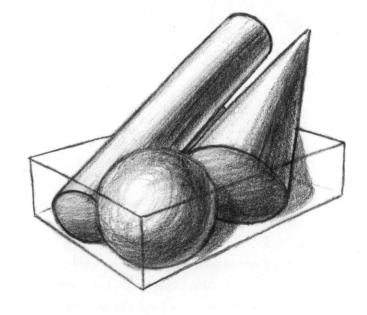

With shading introduced, you can see that each shape takes on undeniably solid form and the whole assemblage exists in spatial depth. From the lack of textural marks, you can also detect that the shapes are quite smooth and featureless.

However, what's most interesting at this stage is that each form has its own shading pattern: straight for the cylinder, converging for the cone and curved for the sphere.

Here the same shading patterns are adapted to natural forms. The areas where the light bounces off an object towards the viewer, making those areas brightest, are called the 'highlights'; the 'local tone' is the tonal value of the objects' inherent surface colour; the areas that face away from the light source and appear dark are termed 'shade'; 'reflected light' describes light that bounces back off the surroundings and partially illuminates shaded areas; and 'cast shadow' results from one element blocking the light from another.

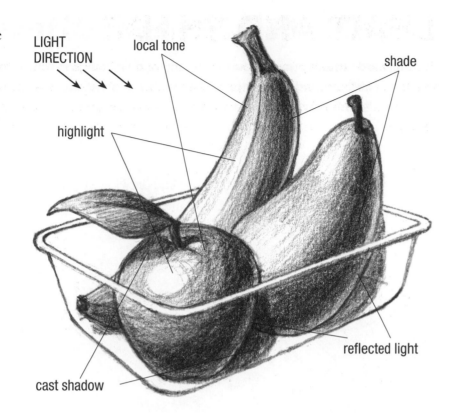

LIGHT DIRECTION

local tone

shade

highlight

reflected light

cast shadow

The shading on this cone and cylinder follows the expected pattern described by Cézanne's shapes and also explains the different textures of the surfaces. Tone and texture are very often dealt with in the same stroke of the pencil.

Here's another conical plant, but this one is composed of lots of spherical masses and is shaded accordingly. The trunk, though cylindrical, starts to divide near the ground, requiring it to be treated like two conjoined cylinders.

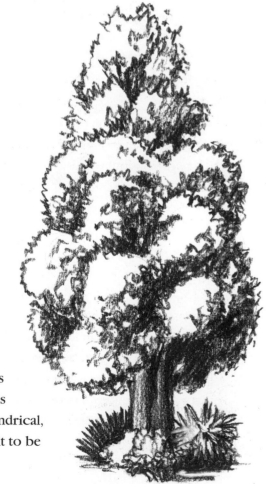

SHADING AND HATCHING

The methods of drawing in tone are many and varied, and may depend on the subject, lighting conditions, materials, personal style and so on. Nevertheless, they mostly boil down to a few essential processes, which we shall now examine.

48

Here I've completed the outline drawing in pen and also worked some texture into the wooden chopping block. The axes look decidedly lightweight in comparison.

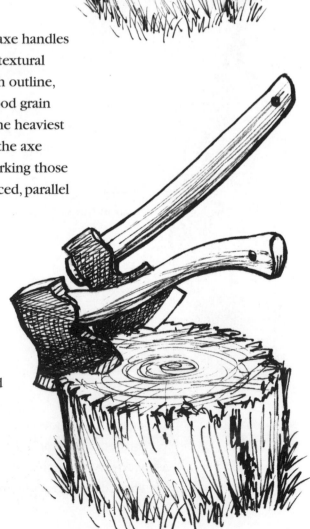

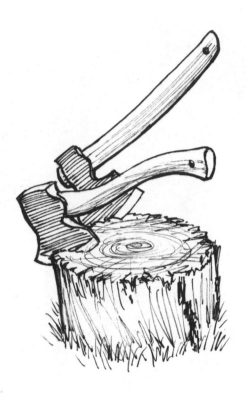

Next I described the axe handles with a few very light textural strokes. With a smooth outline, this reads more as wood grain than rough texture. The heaviest part of the subject is the axe heads, so I started working those with bold, evenly spaced, parallel pen strokes.

To complete the axe heads, I worked over them again in just the same way but changed the direction of stroke. I stopped short of the upper edge, where they are lighter in tone. Repeating the action in a third direction builds up the required density of tone.

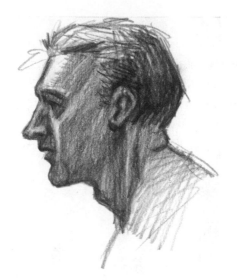

If you look closely you can see evidence of the hatching technique in this portrait study. I used a coloured pencil (a dark, neutral colour) and rendered the face in many different directions so that the hatching blends together, but there are subtle modulations within the tone that are most easily achieved with the hatching method.

All the shading here is done in straight lines radiating from a point above the subject, thereby making a feature of the direct overhead light source.

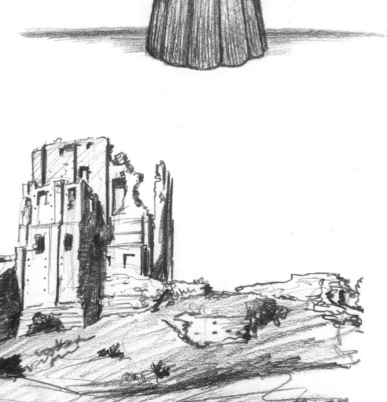

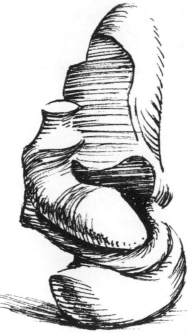

Here the pen lines follow the form of the subject, wrapping around the various parts like contours and helping to describe the solidity of the sculpture.

There are several approaches of rough shading in this sketch, most notably in the lines that make up the castle ruins. Variations in the weight of line suggest the shadows cast by the light relief of the castle walls. In other parts the tone is scribbled loosely with the point of the pencil or, for the softer marks, with the broad edge of the pencil used on its side.

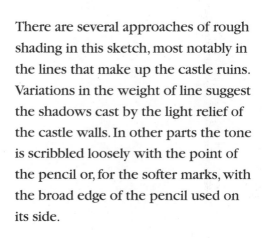

CHARCOAL

So far we have concentrated on pencils and pens, but there are many other materials that offer different drawing effects, especially in terms of mark-making and shading. One such material is charcoal, which is nothing more than charred wood and can be bought very cheaply in sticks of various thicknesses.

This tiny sketch demonstrates the strong dark line and soft-edged, smudgy qualities for which charcoal is known. Working at speed, I roughly scribbled in the darker patches of sky and then smudged them around with my fingertip. Over this background layer, I could then draw the line of trees and bushes with the tip of the charcoal stick, before hurrying away to avoid the rain. Back at home, I used a piece of white chalk to pick out the highlights in the clouds.

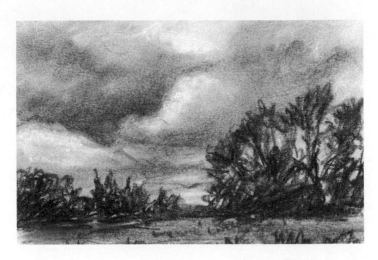

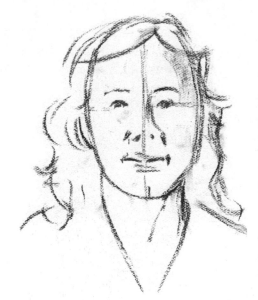

To demonstrate the basic techniques for using charcoal, I sat a friend by a window for an even side light and roughed out the main features and proportions of a portrait with the tip of a broad charcoal stick. Using paper with a lightly textured surface helps to abrade the charcoal as you work and allows for repeated reworking of the drawing.

I broke off a short length of charcoal, about 2.5cm (1in) long, and used it on its side to quickly cover all the areas of shade in broad strokes, pressing harder for the darker parts of the hair. I then softened the skin tones by smudging with a finger. At this stage I wasn't concerned with any details, just the broad masses of tone.

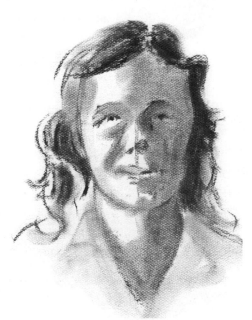

With the tip of a thinner charcoal stick, I set about drawing the features and the main tones of the hair, with careful attention to the model.

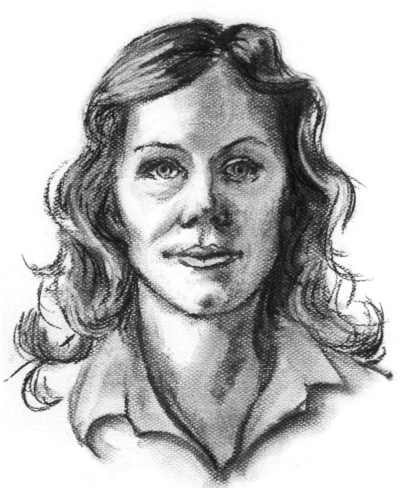

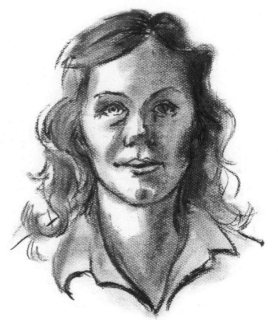

Carefully and selectively, I blended the tones further with the very tip of a finger, trying not to smudge too much detail in the process.

Taking a soft eraser, I cleaned up the grubby marks in the white areas and used the corner to pick out some highlights. I also worked some detail into the hair, with more line drawing and some erased highlights to give it some shine.

ARTIST'S ADVICE

Spray charcoal drawings with artists' fixative spray to make them more stable when they are finished. Hair lacquer does quite a good job too for a fraction of the price, though it can slightly yellow the paper in time.

AERIAL PERSPECTIVE

Now that we're getting to grips with tone, it's a good time to introduce the idea of tonal contrast. Mastery of the contrasts within a picture is another way to control the illusion of spatial depth, so it's considered a form of perspective.

The basic principle of aerial perspective is that as a result of the mass of air, dust and moisture creating haze in the atmosphere, tonal contrasts diminish over distance. So objects drawn with dark lines and shadows and bright white highlights will be read by the eye as being in the foreground, whereas faint marks in shades of grey imply something in the far distance.

Although all the marks here are black on white, the weight of the lines creates the sense of contrast. Foreground features are outlined and textured heavily with repeated marks of a fine drawing pen. The middle ground is drawn with less heavy marks and the buildings in the far distance are indicated with light, broken lines and minimal texture.

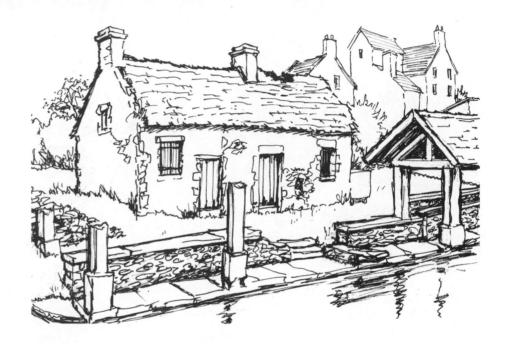

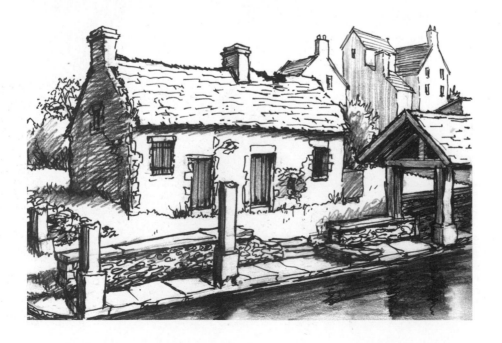

The addition of tone, applied with a soft pencil, further enhances the feeling of depth from foreground to background. I worked the pencil as dark as possible to make deep shade and shadows around the water and columns, but stroked only a faint flat tone over the far buildings to give them some form.

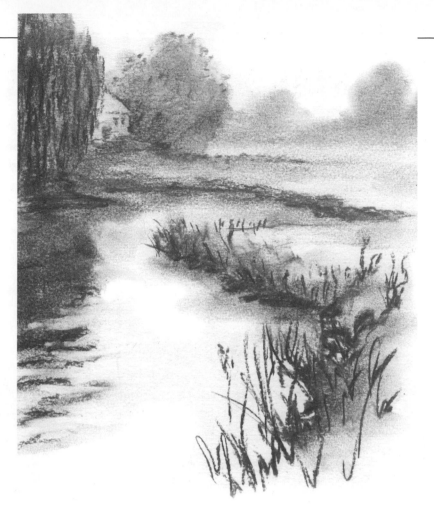

Aerial perspective is best observed in hazy or misty conditions, which exaggerate the effects. Here the landscape, sketched in charcoal, appears as layers of tone, growing increasingly faint into the distance until the land is hard to distinguish from the sky.

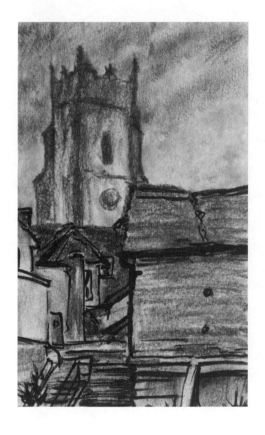

This little charcoal and ink sketch relies on the outlining for its depth. Heavy brush and ink details in the foreground sit forwards of the finer outlining in the middle distance. The background church has no black outline, existing as shades of charcoal grey. The heavy grey sky further reduces its tonal contrast and sets the scene in atmospheric twilight.

Some of the darkest tones in this drawing are to be found in the far distance. It's not always paleness that pushes things into the distance; it's the contrast relative to the foreground. With no brightness in the depths of the woodland, its contrast is low compared to the foreground trees.

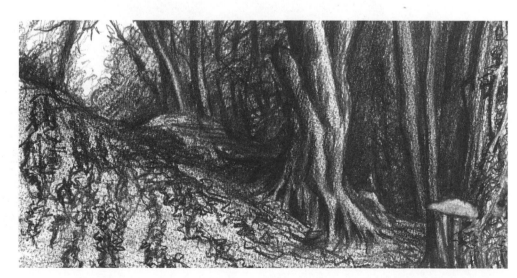

TRANSPARENT MEDIA

As your drawing skills increase in competence and sophistication you'll want to expand your repertoire of techniques to take in other types of media. One technique, very different from the charcoal we've just explored, uses transparent glazes or washes to build up tone and texture in layers that may be easily controlled.

54

The most common and versatile of transparent materials is watercolour. To portray subjects such as this restaurant interior, watercolour is appropriate for its bright, clean tones of subtle modulation.

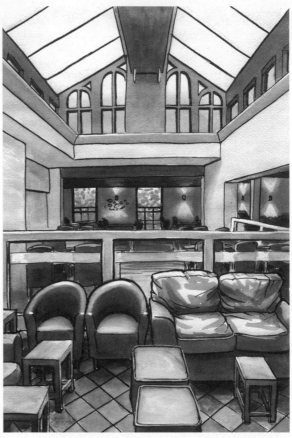

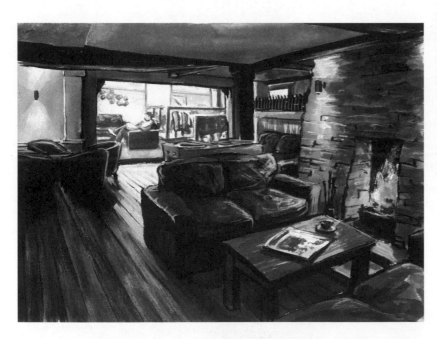

This different view of the same building required a heavier feel, so I used the dense darks of ink in various dilutions.

BRUSHES AND PAPER

It's well worth buying good-quality watercolour brushes, even though they are expensive. I recommend round, soft-haired brushes of sable/synthetic blend. Sizes 3, 6, and 9 would make a good starter set, but one brush of size 6 should be versatile enough for most uses as long as it has good fine point.

Any liquid medium will soak into and stain your paper. Thin paper will tend to buckle with the moisture, so use thicker paper – around 200gsm (120lb) should be sufficiently heavyweight.

BASIC TECHNIQUE

As with any media, there's no right or wrong way to use watercolour or diluted inks, since different subjects will often demand different treatments. Nevertheless, it's useful to look at some stages a layered rendering might typically go through. I selected a simple subject with strong directional lighting and drew a clean outline faintly, including the shape of the shadow.

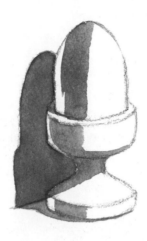

Shade

Mix a little black watercolour or ink with some water on a flat white surface such as a china plate – you need enough liquid to charge and recharge a medium-sized brush easily. Use a scrap piece of the paper you'll be painting on to test the tone of the mixture. Then paint the main areas of shadow in quick motions, allowing the paint to saturate each flat area before moving on to the next. Don't fiddle; once the paint or ink is applied it shouldn't be touched again until dry.

Texture

When the shade is dry, the texture and markings can be applied. Make a slightly richer mix and use the very tip of the brush to draw the wood grain around the acorn and the puckered texture of its cup. Wooden objects make for good practice because most mistakes can be hidden within the wood grain.

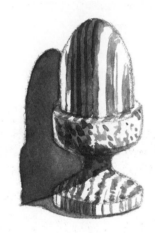

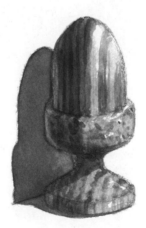

Local Tone

Mix up plenty of light tone and wash it over the entire acorn, cup and cast shadow in swift, broad strokes, taking care to leave it bare where you want the highlights to be. If you go over the edge, or paint into a highlight, the pigment can be lifted off by dabbing with tissue paper.

Fine Tuning

To finish, use a dark wash to state details of extra-deep tone and refine details of texture. The temptation may be to overwork the detail or to apply more layers of subtle tone, but wash drawings nearly always work best when left simple and bold.

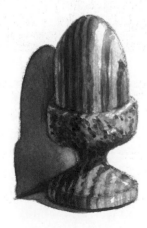

SKETCHING WITH WASH

There's a big difference between drawing in the comfort of the home to make finished pictures or studies and sketching while out and about. In the latter case we tend to ignore a lot of technical process and do whatever is necessary or possible within the limitations of our circumstances. This is often the case when working in wash.

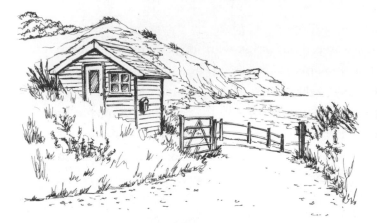

56

Over minimal pencil guidelines I drew the main features with a drawing pen, adding some occasional textural marks but no shading.

With a well-loaded brush of very diluted ink I blocked in the main masses of the shed, cliffs and the upper part of the sky. Washes dry very quickly outdoors, so I was soon able to work some details into the cliffs and foliage with a second layer.

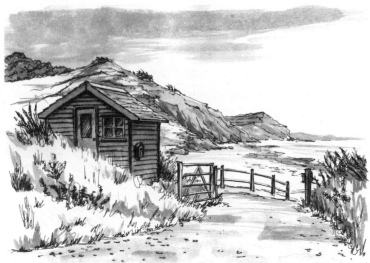

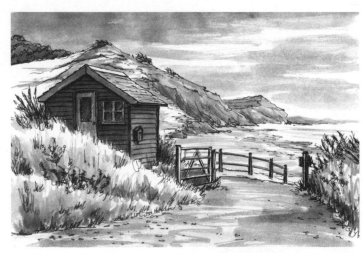

I continued to build up the tones and textures in successive washes. Despite the many layers of wash, the picture retains a degree of freshness as a result of my speedy brushmarks and of leaving parts of the paper clean and white.

> ## ARTIST'S ADVICE
>
> *If you plan to use washes over an ink drawing, make sure that you use a pen with waterproof, or permanent, ink. Watersoluble ink will smudge or wash away with the addition of wet media.*

WATERSOLUBLE DRAWING TOOLS

Drawing pencils, coloured pencils, crayons and pens are all available with watersoluble pigment. They are inexpensive and good for quickly building up richly toned drawings and sketches.

To quickly capture something of the voluptuous solidity of the model, I used a watersoluble pencil just as I would an ordinary pencil and roughly scribbled the broad areas of shade. Then I dipped a stiff brush into some water and painted it over the pencil tone, effectively turning it to paint, allowing me to blend the tones.

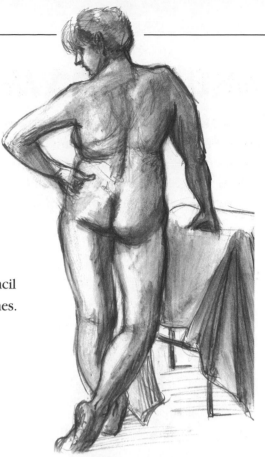

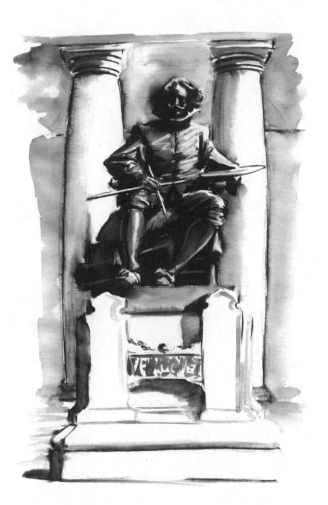

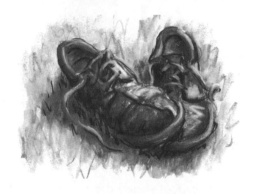

I roughly drew and shaded my old shoes in dark grey watersoluble crayon before painting water selectively over the surface. Once it was dry I added some dark accents with brush and ink and some highlights with a white crayon.

The dense black marks of cheap felt-tip pens can be transformed into a range of greys when selectively moistened, softened and spread around with brush and water. The very instability of the wet ink forces you to work quickly and without fuss.

ARTIST'S ADVICE

It's good practice to leave highlights untouched throughout. No amount of white paint, pencil or chalk will produce a highlight as crisp and pure as that of virgin white paper.

BRUSH DRAWING

The paintbrush isn't merely a tool for applying and blending tonal washes – it can also be a very effective drawing instrument in its own right. The most common medium for brush drawing is black ink, and a small bottle of drawing ink or acrylic ink will last a long time. Make sure that you use ink that is waterproof otherwise any further addition of wash will blur your original drawing.

58

While the portable drawing pen has many practical benefits, it won't always be the most suitable tool. A fine watercolour brush produces lines of varied thickness resulting in more graceful, flowing marks that may better convey the spirit of certain subjects.

Brush and ink is useful to give a deeper shade of black beyond the limits of even the softest pencil. It can be used to bring order and accents to very rough sketches, as in this tonal study.

Different types of brush produce different types of mark. A stiff brush leaves characteristic traces of its bristles, used here for the model's shiny hair. The fine textural marks were made with the brush dabbed semi-dry on tissue paper, a technique known as 'dry brushing'. This drawing also demonstrates the brush's capability to effortlessly cover the paper in solid black.

A bottle of ink is not the easiest thing to handle when sketching out and about, but you can achieve similar results with a felt-tipped brush pen. I did this drawing on location, first drafting very loose guidelines in pencil and then switching to a brush pen for the rest of the work. The flexible tip is capable of many varied marks, which I exploited here to differentiate between all the various textures and surfaces.

TONAL BRUSH DRAWING

For most line drawing, a round watercolour brush in medium size (such as No. 6) with a fine point will suffice. A little doodling practice on scrap paper will accustom you to the feel of the brush and the flow of the ink.

The following exercise involves a range of marks that depend upon the angle of the brush and how much pressure is applied. The drawing is based on a rough sketch of a real scene, but feel free to change any details if you wish to as you follow these basic steps.

60

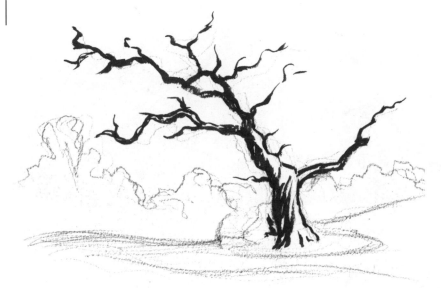

Here I used a small off-cut of textured watercolour paper (about 20 × 15cm/ 8 × 6in), on which I drew a few bare lines of pencil to establish the basic composition. With black waterproof ink, I then drew the trunk and main limbs of the tree. A few strokes were sufficient to indicate the shade and texture on the trunk.

With the very tip of the brush I drew in the smaller branches and a little outline detail of the trees in the background. (Note that this particular tree is old and dying; a healthier example would have many more branches and twigs.)

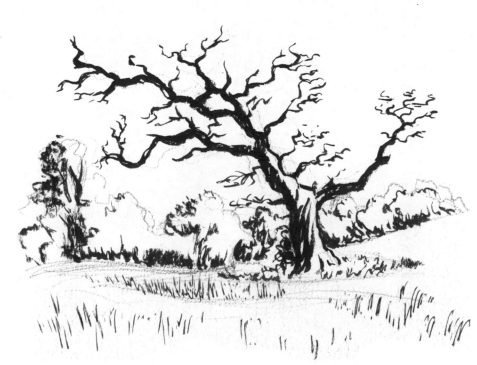

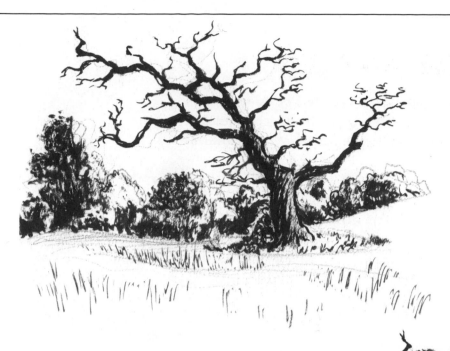

After adding a few strokes in the foreground to suggest the crops growing around the tree, I partially dried the brush on some tissue paper. With the brush semi-inked, I roughly scumbled some textural marks in the background and also on the trunk of the main tree.

I dipped the tip of the brush into some water and, in an old saucer, I worked the water into the brush for a slightly diluted mix with which to block in the distant tree shapes. As I dabbed the end of the brush on the paper its hairs splayed out slightly, allowing me to add loose leaf-like marks for the oak's depleted foliage.

I mixed more water into the ink in my saucer to make it much more dilute. With a larger brush I washed some tone over the field and sky in swift, confident motions. I then used a clean tissue to dab off the areas I wanted to remain white or pale.

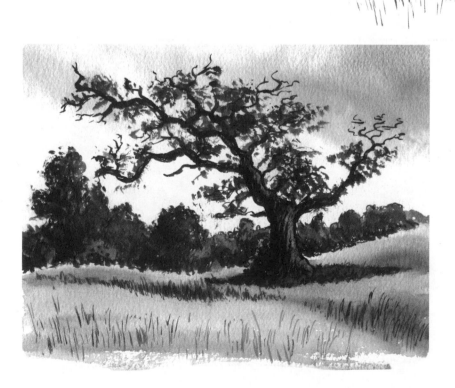

MARKER PENS

Offering some of the qualities of watercolour and inks, two or three artists' quality marker pens could be a useful addition to your kit. They are quick and versatile to use and also have their own unique qualities that are worth experimenting with.

Much like washes of watercolour or diluted ink, marker pens can be repeatedly applied to build up depth of tone. This little study used a single pen of pale grey.

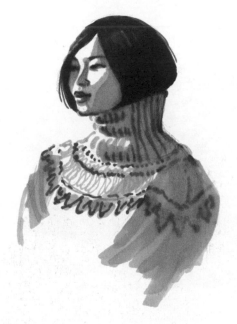

Introducing a second tone makes for richer tonal contrasts. The stark difference between two shades of grey can be softened by working the lighter pen over the darker marks, seen here in the patterns and textures of the pullover.

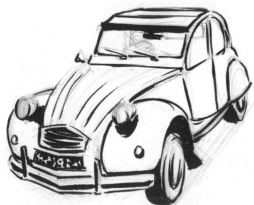

Where marker pens really prove their worth is in their blending capabilities, which can give a look of slickness to even quite rough drawings. I did the loose outlining here with a black felt-tip brush pen and filled in the areas of very deepest shade as solid black.

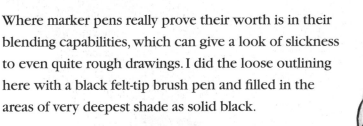

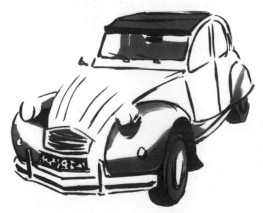

I used three shades of grey marker to build up the tones, starting with the darkest, filling in broad areas. The hard edges don't matter because they will be softened with subsequent paler layers.

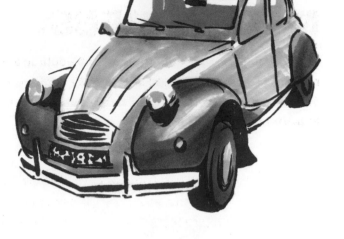

With my medium-tone pen I covered areas of mid-tone. Where I met the darker tone, I worked the mid-tone pen into it, thus roughly blending the tones into each other.

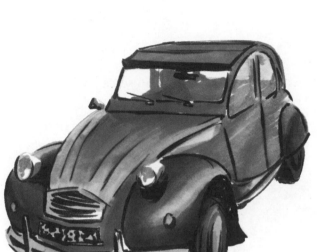

63

With a third, paler grey, I worked over the entire car, paying special attention to the areas of graduated tone to blend them smoothly.

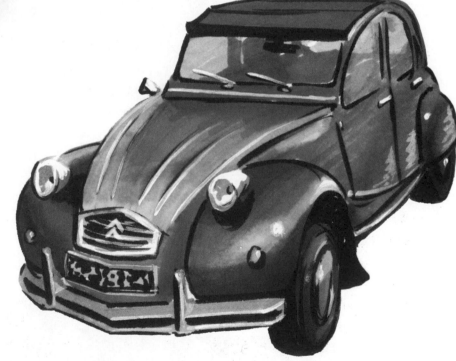

When working vigorously and aiming at a fresh, loose feel, it's not always possible to avoid getting ink over the required areas of highlight. However, they can be applied on top of the artwork using an opaque white medium. Here I used white drawing ink and a fine brush, working in swift strokes to retain the carefree flavour of the line and tone drawing.

ARTIST'S ADVICE

Oil and water don't mix, so spirit-based pens won't affect a drawing done in water-based ink. In this respect the choice of material for highlights may be important. If in doubt, do some tests beforehand.

OPAQUE MEDIA

On the previous spread you saw how white ink could be employed to put in highlights on top of darker marks. The dense covering power of opaque materials allows you to draw light over dark in various ways for various effects. Different materials have their own characteristic marks and differing degrees of opacity.

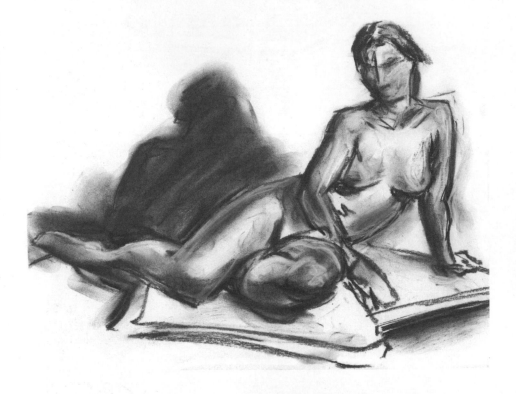

Here I used a dark grey pastel for the main drawing, smudged here and there with a fingertip. To add the highlights, rather than carefully trying to erase back to the white paper it's quicker and more sensitive to use a white pastel over the top of the dark drawing. The two tones can be blended by smudging, if required.

TONED PAPER

Working on grey or black papers, or 'toned grounds', allows for clear and dramatic use of opaque materials, as this sketch demonstrates. It took no more than a minute to roughly paint on the highlights with white ink, yet the result is quite dazzling compared to the earlier stage.

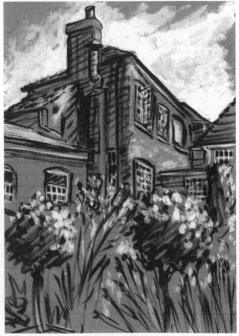

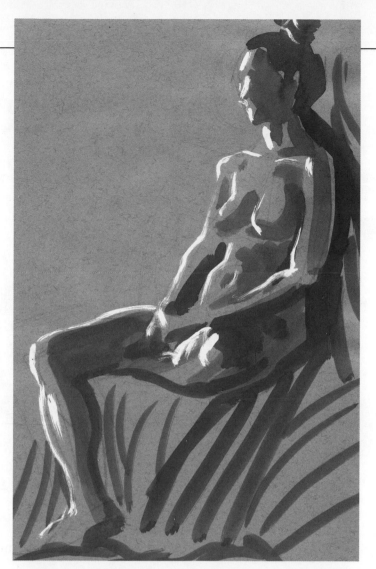

▶ With mid-tones already established by the paper, you can concentrate on the lights and darks and draw with economy, resulting in quicker, cleaner drawings. White ink applied with a thin bristle brush over a sketchy ink wash drawing leaves bright highlights that economically describe the model's outer contours.

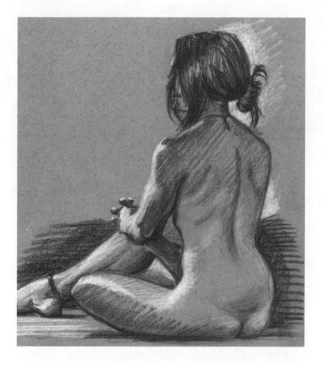

▲ Pastel pencils produce a delicate, pressure-sensitive mark, well suited to hatching subtle shades and tints. The white is not so bold as in other materials; strength of opacity must often be sacrificed for sensitivity.

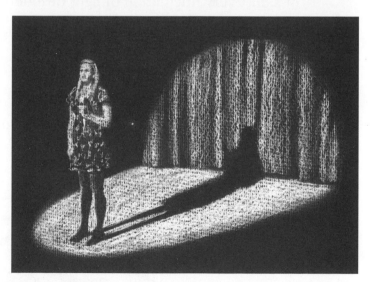

ARTIST'S ADVICE

When working on toned grounds, it's often a good idea to leave a generous amount of the surface unworked, with the ground tone showing through.

▲ On toned grounds, a drawing may be done entirely in white or pale opaque material. This can be especially effective when working on very dark paper with subjects of bold lighting or tonal contrast, such as this pastel study.

PART II: *Seeking essential truths*

66

Just as important as what you draw is how you draw it, and yet even more essential is what you don't draw. No drawing can hope to comprehensively include the full breadth of our penetrating vision – every blade of grass, every pore of skin, every fluctuation of light or modulation of tone – but in any case much more can be achieved by intelligently restricting the scope of our drawings. Any subject embodies many different qualities; an apple may be simultaneously round, solid, shiny, green, blemished and so on, and it's up to you as an artist to decide what you want to convey. And it turns out that the less you try to cram into a drawing, the more interesting it will be.

So, we begin part two of this book with exercises in self-imposed restrictions. It may sound contradictory, but placing restrictions on your working practices is actually very liberating and will quickly develop your creative instincts. We shall look at the practical limitations of sketching beyond the comforts of home, experience of which will inform your working practices and encourage you to use your tools and materials with efficiency, playfulness and individuality. These lessons will lead you into the real work of distilling your subjects into drawings of elegant simplicity.

Rather than slavishly copying every aspect of a subject, we shall instead seek to convey single essential truths. Different subjects will naturally suggest certain treatments or experiments, always with the clear objective of illuminating their particular physical and emotive qualities, so various methods and materials will be further explored and demonstrated throughout. Interesting drawings will inevitably result and you'll discover that from simple aspirations can come drawings of expression and effectiveness.

FRAMING AND SELECTION

As you progressed through the first part of the book you will have noticed that the drawings increasingly included background features or tone, resulting in them spilling beyond the clear boundaries of a subject's outline shape. In other words, the pictures were beginning to fill rectangles. So at this point we must consider the extent of a drawing's edges, or 'framing', and the effects that such decisions may have on our drawings.

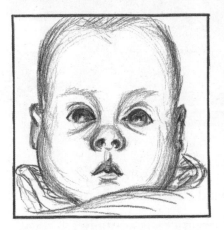 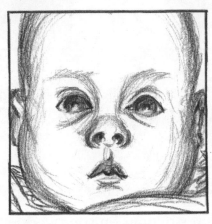 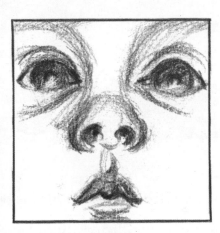

Here are three versions of the same sketch. The features and expression of the baby are the same in each, but the closeness of the framing lends each a different feel. As is often the case, including less in a drawing can actually increase its impact.

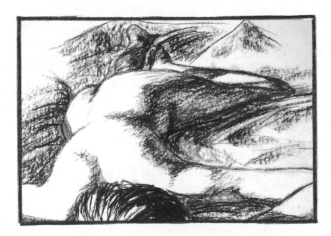

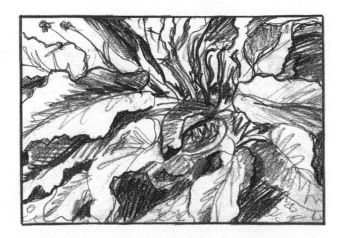

Selecting only a part of a familiar subject can make it more ambiguous and therefore more intriguing. Thus an unremarkable life drawing can take on qualities of landscape or abstraction.

A similarly abstract feel is achieved by the close framing of this plant sketch. Allowing the drawing to extend to the very edges of the frame gives the drawing a crowded feel, making the plant seem bigger and more vigorous.

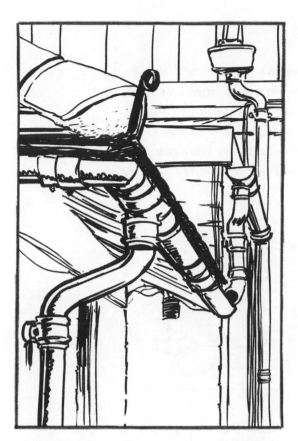

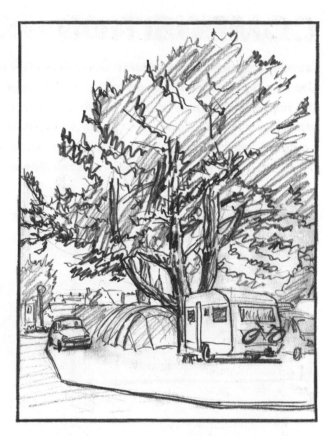

A creative eye can find interest in the most unexpected places. Selecting an interesting viewpoint and an effective framing here elevates a mundane collection of drainpipes to a subject worthy of attention.

At other times it may be appropriate to include more of the details around a main subject. A huge, spreading tree canopy provides a charismatic campsite setting.

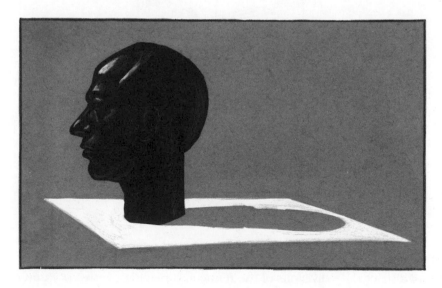

Some subjects seem to need plenty of breathing space, creating a mood of dignified calm. This carved head benefits from the inclusion of its shadow, which is allowed space to be as much a part of the picture as the main subject.

ARTIST'S ADVICE

It is perfectly valid to alter a framing after a drawing is finished, by erasing, masking or even cutting off the unwanted edges.

COMPOSITION

More sophisticated considerations of framing come under the heading of composition. In art, the term refers to the organization of elements within a frame, the foundations upon which a picture is built. A clumsily composed picture will always look weak, however well drawn the details may be, whereas a strong composition will shine through the clumsiest of drawing techniques. Here are just a few tried and tested methods for achieving accomplished compositions.

The most elementary composition places the subject in the centre of the frame. While this isn't very dynamic or exciting, it may suit some subjects and can look accomplished with an interesting interplay with surrounding elements. In this case the vegetables are arranged to follow a loose spiral into the pot.

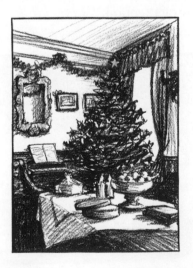

Invariably, though, it's more interesting to place the subject off-centre. The Ancient Greeks had a strict formula for the ideal division of a space to produce what was called 'the golden section'; some artists refer to the 'rule of thirds'. Both 'rules' suggest that satisfying compositions will result from making divisions of the frame and placing centres of interest at around three-fifths or two-thirds respectively along the horizontal or vertical dimensions of a picture.

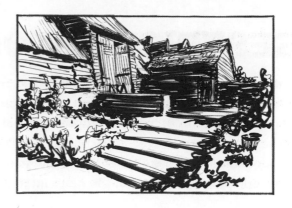

Heavy tones carelessly placed within the frame can make a picture seem lop-sided, so imagine a composition pivoting on its focal point, with the weight of tone having more or less effect over distance from the pivot, and aim to balance the whole. If this is reduced to blocks of pure tone we can tell at a glance if a composition looks tonally balanced.

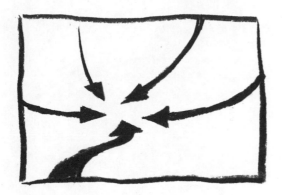

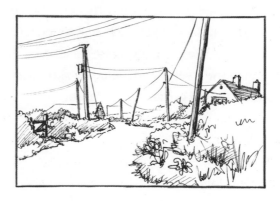

A successful composition can direct the viewer's eye into a picture towards a focal point by means of directional lines. A road or river naturally leads the eye, as do other linear features, such as the hedges and telegraph poles here. If such leading lines follow graceful curves the composition will seem to flow.

ARTIST'S ADVICE

A simple viewfinder is a great help for visualizing different compositional framings. Cut out two 'L' shapes of cardboard and attach them together with paper clips to the proportions you desire. You can then hold the viewfinder out in front of you to observe a subject or scene within the limits of a frame. These 'L' shapes are also useful for helping you to decide on alternative framings for finished drawings.

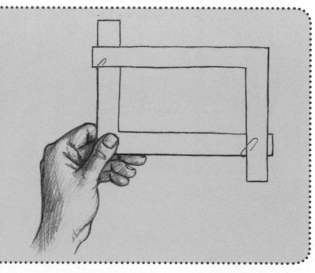

RESTRICTED TONE

In drawing we can only hope to mimic about one per cent of nature's vast tonal range from total darkness to brilliant sunshine. Trying to capture every subtle modulation of tone in between is a painstaking task that usually results in drawings that are over-fussy and stiff. It is surely more fun to embrace our inadequacies and make inventive use of tone. Indeed, it often turns out that the less sophisticated the tone, the more interesting the drawing.

72

For tonal drawing it's often necessary to take tight control of the tones within a picture for the sake of readability. Here I was faced with a grey bird on mid-toned branches amid generally mid-toned foliage, so I made the decision to exaggerate the tonal differences, lightening the foreground elements and pushing the background into greater tonal depth.

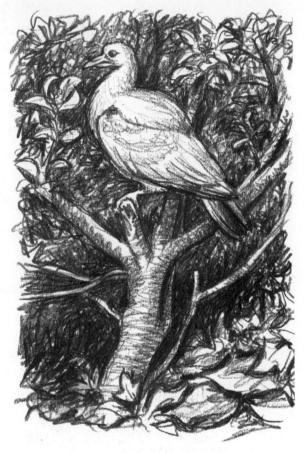

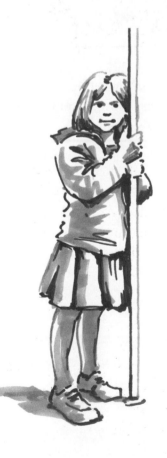
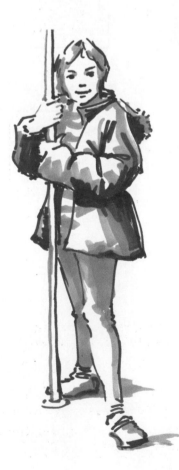

Here I restricted the tones to two shades of grey marker pen. I did most of the drawing in pale grey and then added details and accents in the darker tone, ensuring that I left a good amount of white paper showing through.

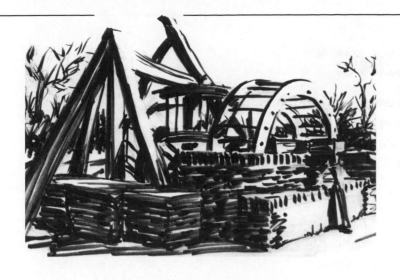

When you are sketching with a brush pen, the stark blackness of the mark forces you to make firm tonal decisions. Each part of the picture must be contrived as either black or white, although the pen can be quickly grazed across the paper for rudimentary shading that acts as a grey.

Against a snowy background in dull conditions, this branch made a naturally monotone subject. There was little interpretation required, but I did make a conscious decision to draw no outline of the snow resting on the branch, instead allowing the spaces within the drawing to make the necessary suggestions.

It can be very effective to leave parts of a drawing unstated, allowing the viewer to mentally fill in the gaps. The trick is to draw the whole thing first so that when you do the final inking you can be sure that the drawing works structurally.

ARTIST'S ADVICE

Drawing in restricted tones works particularly well in bright lighting conditions. Try to ignore local tones and concentrate on the fall of light and shadow. Think of cast shadows as essential elements of a composition.

CONTINUOUS LINE

Setting out to draw in continuous, flowing lines can help you to free up any tendencies to overly fussy and precise drawing. This technique often results in characterful drawings that would be difficult to produce by more measured means. The only rule is to resist the temptation to lift the pen or pencil from the page.

Detailed bindings make a mummy an ideal subject for this approach, allowing the unbroken line to describe the form in overlapping contours. In contrast, the sleek curves of a classic car translate less well, but result in a drawing of quirky charm.

The free-moving pencil can also be employed for degrees of tonal modelling when used in more vigorous actions. Even for drawings of heavy tone, the intention to keep the pencil on the paper stimulates a freedom and looseness of mark-making.

To ensure a sound structure and composition, I loosely pencilled the main masses and perspective angles. Then I took a fine drawing pen and started working on a detail at the top left. I tried to avoid my tendency to backtrack, which meant moving from one element to another, often leaving the first incomplete. I only lifted the pen when it ran off the edge of the page.

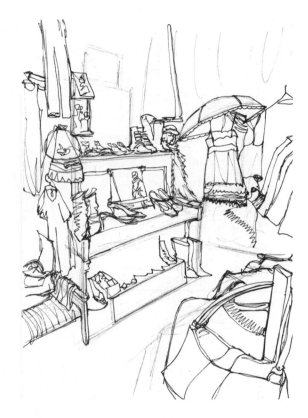

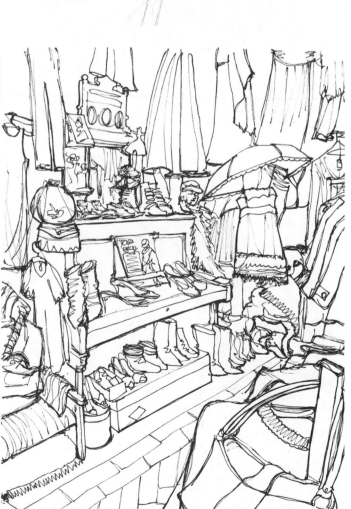

I continued in the same manner from other starting points and gradually the parts of the scene joined up. All the while I made meticulous observations of the individual items, trying to translate their characteristic shapes and materials in the rigid line of the pen.

As the picture progressed I needed more and more starting points until I completed all the items and filled in all the gaps. I then used a broader pen to add definition to certain outlines. This is not within the strict rules of the exercise, but rules and restrictions are merely for guidance; ultimately it is the picture that matters.

BLUNT INSTRUMENTS

A really good way to keep your drawing loose and fresh is to work with tools that don't allow very much precision, forcing you to draw with broader sweeps and gestures and inventive mark-making. The results are often surprisingly effective.

Here I used a short stick of black pastel turned onto its flat edge, which turned out to be ideal for the soft tones of the horse's coat and equally effective for the sharper outlines of the mane and tail. I am also pleased with how the straight edge of the pastel worked for the grass texture.

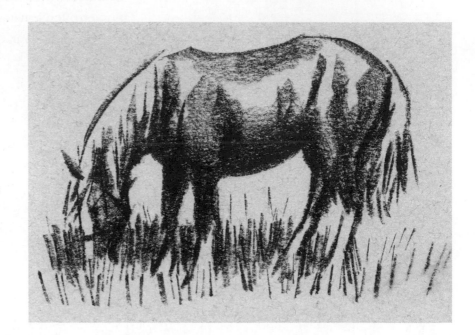

76

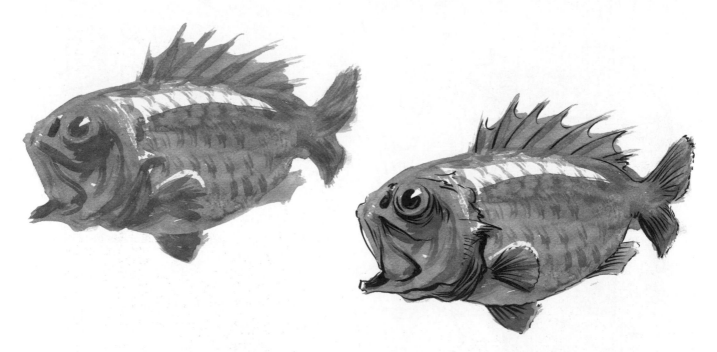

With an old, splayed watercolour brush heavily loaded with diluted ink, I painted the crude outline form of a stuffed fish. I left some areas clear for highlights and also worked the ink more heavily around some of the details. The result has a looseness and textural feel that I wouldn't have achieved by working more meticulously. It was then quite easy to sharpen up the rough drawing with a fine brush and black ink.

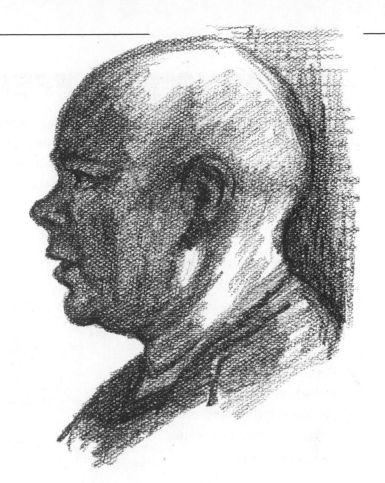

With the subject in shade and using a blunt crayon on heavily textured paper, there is little opportunity for precision. However, working the crayon repeatedly into the paper soon builds up definition around the features as well as quite subtle gradations of shade. It is a satisfying and unpressured way of working.

Working with a broad bristle brush, my challenge was to convey something of the subtleties and finery of this Egyptian golden mask. I found myself putting on the ink in confident fat slabs and then scrubbing the semi-loaded brush into the paper for various mid-tones and markings. For delicate highlights I used white ink and merely touched the tip of the brush on the paper.

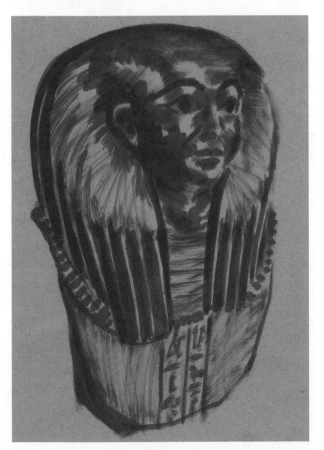

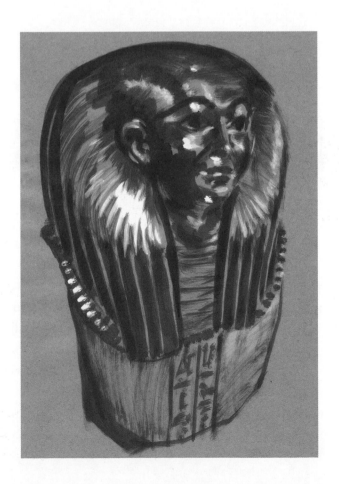

WORKING AT DIFFERENT SCALES

Another way of stepping outside your comfort zone and changing your habits is to work extra large or small. In doing so, you will find yourself holding your tools in a new manner and using different movements of the hand and arm that may unlock techniques you can then develop in your everyday drawing.

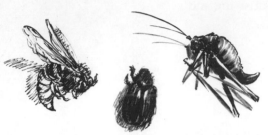

I drew these dried insects life-size, using very fine pens and sharp pencils. Even with the aid of a magnifying glass it was difficult to observe the finer points, so it was necessary to make rough approximations of details and surfaces. Furthermore, every tiny movement of the hand had quite an effect on the drawing, so the marks had to be made with conviction.

Even in enlargement, such tiny drawings can look surprisingly convincing, free and unhampered by unnecessary fuss.

The same approach can work well for subjects of any size. I drew these larger subjects at no more than 2.5cm (1in) across, so the scale limitation made it impossible to include every detail. Working in this way forces you to be selective in what forms to feature and any shading and textural marks you employ.

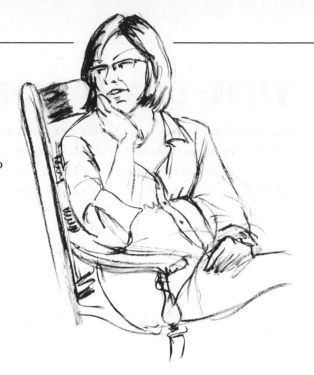

At the other end of the scale, larger drawings demand that you stand at arm's length from the drawing board and use big motions from the elbow and shoulder. I did this portrait at A1 (84 × 60 cm/33 × 24in), which allowed me to draw the model at life size. For the initial stage I drew very loosely with charcoal, just laying down the general pose and proportions.

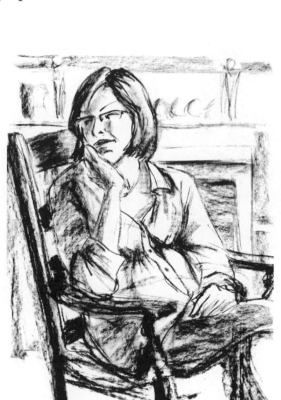

Turning the charcoal on its side, I used broad sweeps to draw the main areas of tone and also to indicate some rough background detail.

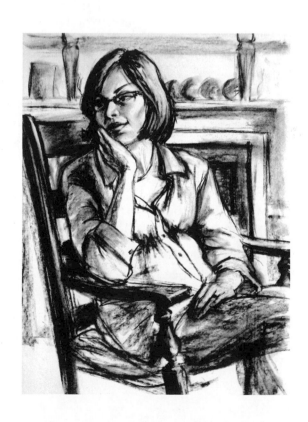

The scale of the drawing made it quick and easy to work the rough charcoal into a more finished portrait, smudging the tones with my fingertips and reworking details with more charcoal. For highlights and corrections, I used a large eraser in similarly swift strokes.

ARTIST'S ADVICE

When you are working at a large scale, try to fix your paper upright on a drawing board, door or wall. Working flat on the floor or table can mean you view your drawing at an angle, leading to distorted proportions.

TIME LIMITATIONS

Much of the artwork seen so far has been drawn quite quickly, albeit often with careful advanced thought and planning. This way it retains a boldness that can easily get lost if it has been worked too meticulously. Yet, despite the best of intentions, it's easy to get waylaid by details or too involved in a drawing to stop at the optimum point. To counter any such tendencies it's good practice to undertake some exercises with strict time limitations. You may be surprised at what you can produce under pressure.

80

Here my desire to eat the breakfast overruled my tendency to fussy drawing. Working on a toned ground sped up the process too, as did the use of pastel pencils, which produce rich tones quickly.

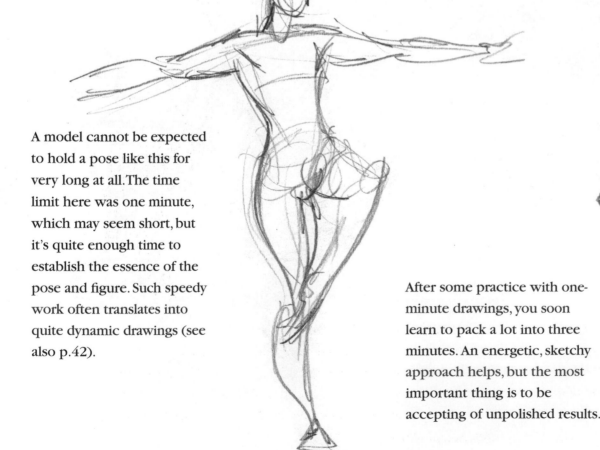

A model cannot be expected to hold a pose like this for very long at all. The time limit here was one minute, which may seem short, but it's quite enough time to establish the essence of the pose and figure. Such speedy work often translates into quite dynamic drawings (see also p.42).

(see also p.42).

After some practice with one-minute drawings, you soon learn to pack a lot into three minutes. An energetic, sketchy approach helps, but the most important thing is to be accepting of unpolished results.

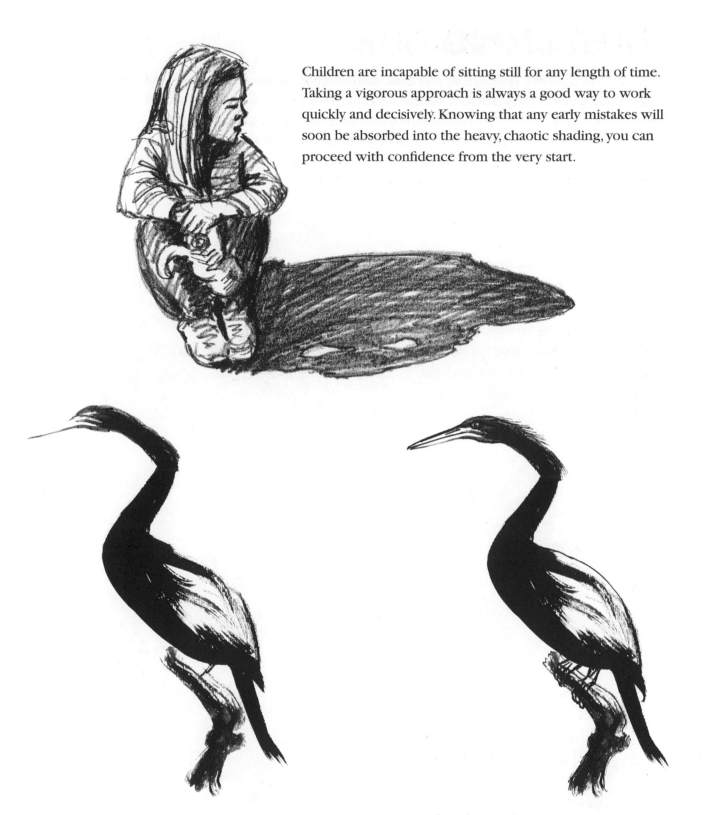

Children are incapable of sitting still for any length of time. Taking a vigorous approach is always a good way to work quickly and decisively. Knowing that any early mistakes will soon be absorbed into the heavy, chaotic shading, you can proceed with confidence from the very start.

In the tradition of oriental brush drawing, I spent quite some time looking at my source photograph and mentally rehearsing my brush movements before rapidly committing this cormorant to paper. The speed of execution and the associated textural marks are vital to the flavour of the drawing. Once it was dry I could add some selected details at leisure.

SKETCHING

Most of the pictures featured in this book have been done in sketchbooks on location. If you're serious about improving your drawing skills, it's essential to get out and about with a sketchbook as often as possible. Sketching takes many forms, often depending more on circumstances than artistic inspiration. Here are some tips on how to make the most of the circumstances you may find yourself faced with.

Before photography, artists sketched to record information for use in finished artworks. In the same way, sketching can be thought of as a means of gaining familiarity with certain forms and subjects and practice at drawing them. Try some sketches that include as much detail as possible, however roughly drawn.

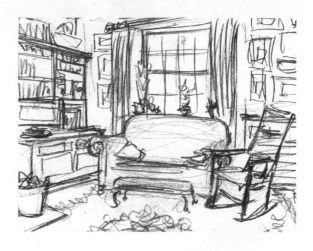

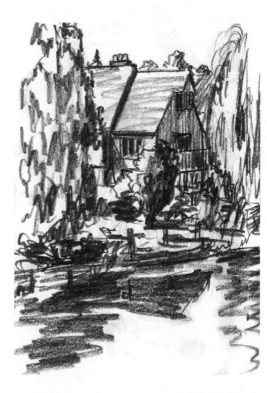

Sketching objects from unfamiliar angles sharpens your drawing skills and increases your knowledge of the subject. You may also get interesting results.

Appropriate mark-making can describe textures and lighting economically, bypassing a lot of time-consuming detail. Here the hanging foliage is rendered in simple, vertical strokes, while their reflections are conveyed in broad horizontal slabs of shade.

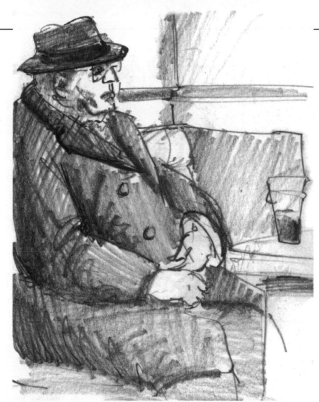

Get into the habit of carrying a small sketchbook around with you. Even the busiest person can find time to sketch in the odd moments between activities. Wherever you are there will always be something worth drawing.

ARTIST'S ADVICE

Think of a sketchbook as a private diary. Use it to scribble down any odd details, compositions, rough doodles, ideas and experiments – whatever catches your eye or fires your imagination. Just a few strokes of the pencil can make a sufficient record of an idea that may otherwise become lost to you forever. The important thing is that you shouldn't feel inhibited by what anyone might think, because nobody else ever needs to see it.

Drawing strangers helps to pass idle moments very pleasantly, but demands a degree of discretion. Hold your sketchbook out of sight, if possible, and try not to face your subject. Don't stare for long periods, but take quick, tactful glances. The more you practice, the less you will have to look at the subject to take in the information you need.

It is only when you start drawing people that you realize quite how much they move about, even when performing repetitive actions. For groups of people it makes sense to keep the whole sketch on the go, flitting between the individual figures as they assume the appropriate positions. This simple-looking sketch took about 40 minutes, built up with an arm here and face there and a fair bit of waiting in between.

Sketching (continued)

Children and animals are notoriously difficult to sketch because they are constantly on the move. Trying to persuade them to stay still makes them fidget all the more and makes for stiff, unnatural poses. Catch them when they are absorbed in an activity and unaware of your presence – and draw them quickly.

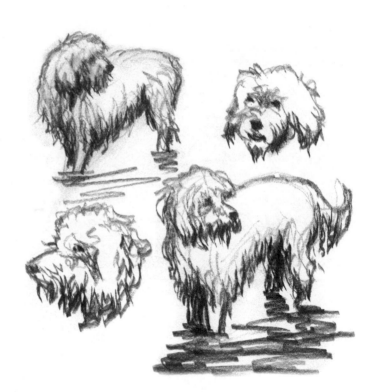

ARTIST'S ADVICE

To draw moving subjects, work on several studies simultaneously, switching between them as the subject shifts pose. Work standing up so that you can easily shift your own position for the views you need. Be bold and make your marks count.

Facing the challenge of uncooperative subjects soon sharpens up your skills of economy and invention. For this wading dog I held the pencil at a very flat angle and used the side of the lead to capture the tone and texture of the wet fur in swift up and down movements. The same grip with gentler sideways motions quickly approximated the fluffier upper surfaces of the animal.

Exhibits in museums and galleries, being inanimate, allow you as much time as you like, giving you practice at sketching complex poses or challenging angles of view. With a static subject you also have the time to work in different materials, but it's wise to limit your sketching tools to what you can comfortably carry in your pockets and handle standing up.

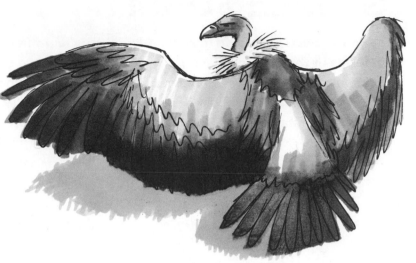

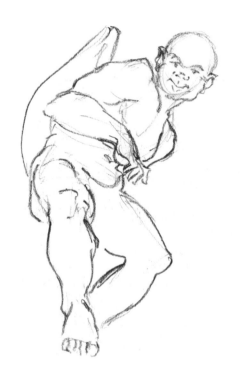

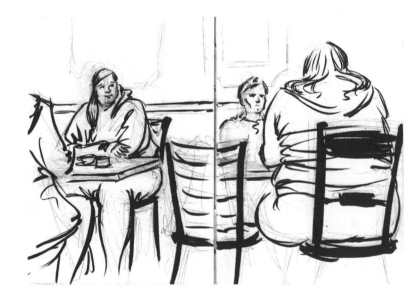

Sketches that cannot be finished on the spot may be developed later. In a café, I jotted down all the important details across two pages of my pocket sketchbook, using a brush pen over rough pencil. Later on, working from memory, I developed the sketch into a more finished drawing.

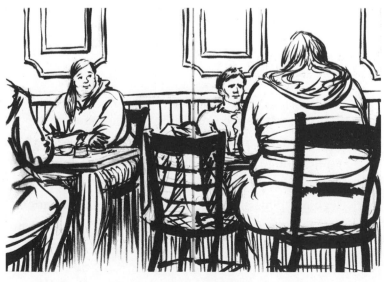

SIMPLE FORM

Form has been discussed in some detail throughout this book so far, generally in terms of the practical description of objects. Here we shall revisit form as a concept worthy of self-contained artistic statements – where the focus is on the formal elements that say something about a particular subject or that seem interesting enough to make satisfying finished artworks.

The gentle yet descriptive undulations along the frog's head and back, the way its body wraps around the stone, the voluptuous fleshiness of the limbs, the contrasting proportions, the delicate fingertips, the almost-human smile . . . All these and many more qualities make the pure form of this museum exhibit a subject satisfying enough without adding any complications of light and shade, texture, setting and so on.

In this pocket-sized sketch the basic outlines of the cows are sufficient to describe the scene, but there's also something in the ambiguities between the individual creatures that helps to convey the eager crush of the feeding animals. Adding tone or texture might enrich or clarify the scene, but it would be likely to detract from the overall feeling.

With subjects as charming as these old Malay puppets, a basic outline of their shapes and features is sufficient to do justice to their simply styled design.

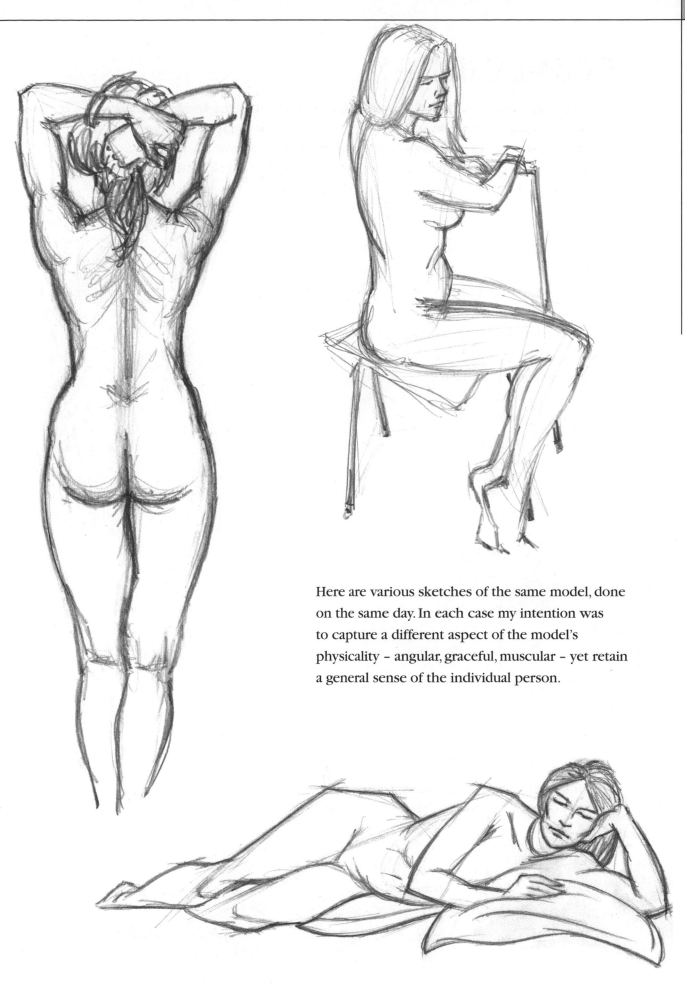

Here are various sketches of the same model, done on the same day. In each case my intention was to capture a different aspect of the model's physicality – angular, graceful, muscular – yet retain a general sense of the individual person.

ELEGANCE

Beauty is very much a subjective concept, but there are many things that are generally agreed to conform to standards of prettiness, elegance or purity. It's not necessarily the case that such subjects will automatically make for elegant drawings; it may require a conscious effort to bring out the beauty in your drawing approach.

I liked the graceful form and pose of the seated model on the previous page, but the roughness of the execution does somewhat spoil the elegance of the sketch. To make a cleaner version, rather than erasing the original and redrawing it, I made a tracing. To do this, I placed a clean sheet over the original and then put both sheets on a windowpane, which enabled me to see the original clearly enough to redraw the picture in a more graceful manner, using a soft pencil. I also replaced the unattractive chair with one that better suits the subject.

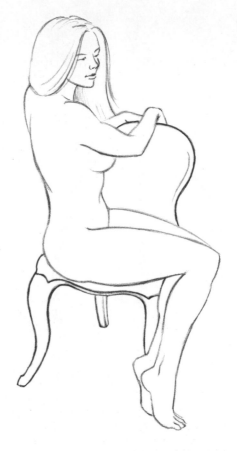

Though the hair here is dense black in parts, I left the highlights quite pale for a sense of lustrous texture. In contrast, the face is barely modelled at all, leaving out any potentially distracting lines and hollows and relying instead on the distinguishing features, drawn in soft outline.

ARTIST'S ADVICE

It's generally easier to reinforce light pencil work than it is to clean up lines that are too heavy, so if you want a feeling of gentleness, start off light and firm up gradually.

A medieval castle is not a subject one would naturally equate with elegance, but there's a fineness to the form and detailing of this example that can be brought out with a sympathetic line treatment. Again the omission of heavy shading and texture aid the effect, as do the simple point of view and composition.

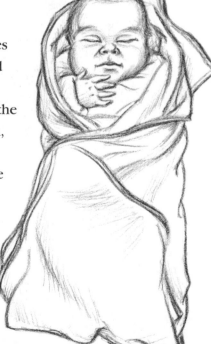

The soft, waxy mark of a coloured pencil makes it easy to avoid the deep tones and harsh edges that would spoil the gentleness of a subject such as this. I kept the shading to a bare minimum, just enough to describe the roundedness of the face and the undulations of the fabric. The symmetrical view adds to the feeling of calm.

Among the trees in a park, one stood out for me for its shape and stature. To bring this out in a sketch, I positioned myself for an uninterrupted view of the tree. Though the treatment is quite rough and textural, the shape of the tree snaking its way up the page makes for an elegant silhouette, especially in comparison with the more cluttered lower part of the drawing.

SYMMETRY

Although front-on views do not generally make for exciting or dynamic drawings, there are some subjects that lend themselves quite naturally to having their symmetrical aspects focused upon. The effects of such formal viewpoints can be quite varied, according to the subject and the artist's treatment of it.

The heavy outlines and low viewpoint work together with the formal symmetry to make an imposing view of this library building.

Although we may think of them as symmetrical, in reality most faces are rather lop-sided, so some tweaking may be required here and there to make a face conform to a symmetrical treatment. Here the fixed gaze of the model makes an impact and all surrounding details have been omitted to make the most of it.

A distant and symmetrical view brings out the formal elegance of this Georgian mansion. Although the effect is almost diagrammatic, it is broken up by the off-centre, organic qualities of the mansion's surroundings.

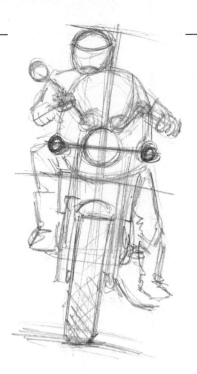

Although symmetrical views can look quite precise and technical, they need not involve laborious drawing processes. Here I started with a very loose, rough under-drawing while a friend posed on his bike. I got the basic masses in place and then took a photograph to continue working from.

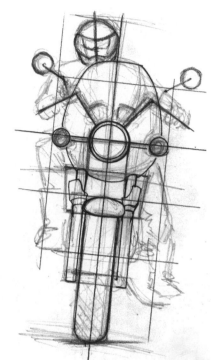

At my desk, I ruled a rudimentary grid over the rough drawing, starting from a centre line. With the grid in place I could draw the main parts of the bike with pen and ruler and some circle templates for the lights.

After completing the general outlines I erased all the pencil marks. You'll notice that there are many mistakes, but most of these can be quite easily absorbed in the next stage.

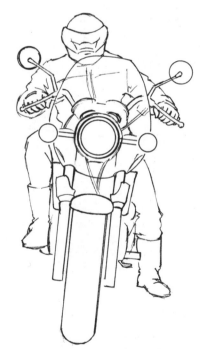

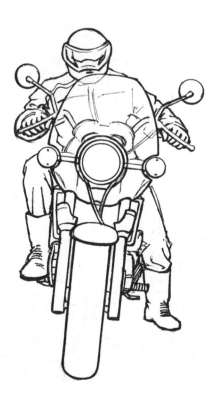

With symmetrical views, any asymmetrical parts look immediately wrong, so work on details either side of the centre line, making any necessary adjustments to ensure both sides match.

When strengthening outlines you always have the option to work either side of the line, effectively allowing you to shift the line slightly and adjust slight divergences from symmetry. (See p.102 for the final rendering of this drawing.)

GEOMETRY AND STRUCTURE

Beyond symmetry, subjects may possess many other kinds of formal and structural qualities that may be brought out as special features in your drawings of them.

What attracted me to this cat on a cushion was the contrast between the roundedness and the angular. I started the sketch in pencil as a simple circle on a square and tailored the ballpoint pen outline to roughly follow the geometric shapes.

The rigid grid-like structure that I brought to the fore in this sketch makes for an oppressive feel, pressing in on the figures from all sides, and enhanced again by the tight letterbox framing.

Huge and bizarrely shaped bushes threaten to overwhelm a shed, crowding in from all sides. To accentuate the shed's plight, I focused on the solidity of the hedges, with heavy modelling to bring out the individual shapes and engulf the shed.

The rigidity of the design is what interested me in this rocking horse, so I chose a formal side view and made the decision to draw it without any perspective. I drew all the main lines strictly vertical or horizontal and simplified the curves.

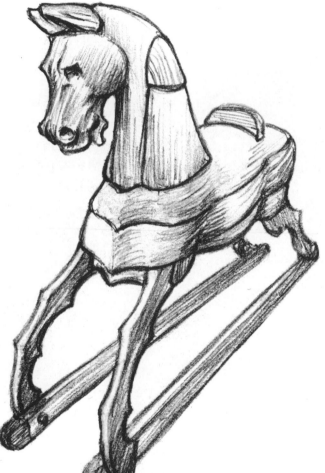

I was interested in all the individual panels and blocks that make up this restoration project, stripped of its layers of paint and finish. In my drawing I exaggerated the divisions with heavier lines and also varied the shading direction to follow the wood grain of the separate blocks.

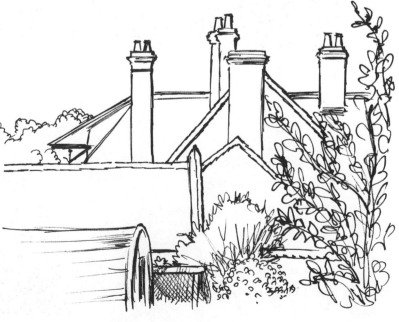

Drawn from a distant, dispassionate viewpoint and devoid of detail, tone and atmosphere, this scene becomes a study of the triangles, uprights and horizontals that comprise the roofs of a farmhouse.

BRIGHT LIGHT

Without light there can be no vision and no drawing. In a sense, then, light is present for every drawing, but it takes a conscious decision to make a feature of it. Drawings can focus on many different types of lighting conditions, the most obvious of which is seen in the effect of great brightness.

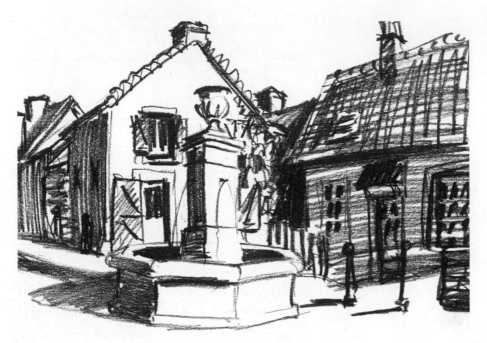

Bright light tends to have the effect of increasing tonal contrast. Illuminated areas become very pale and shadows are very deep and dark. To sketch such conditions, ignore local tones and draw only the areas of shade, leaving lots of white for the palest areas. In reality, this scene had grey paving, sandy-coloured stonework and a deep blue sky, but shading them would greatly lessen the impact of the blazing sunlight.

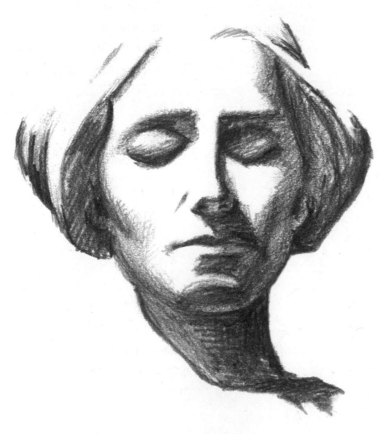

Light alone may be enough to describe a subject. Here there is no outline, no texture, and very little nuance of tone between dark and light. The bleaching effects of light make it perfectly reasonable to allow the brightest parts to run off into pure white, an effect that is often quite pleasing to the viewer.

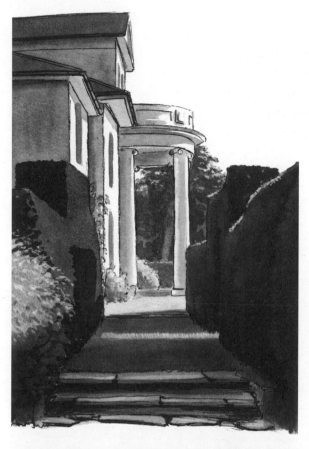

Here the brightly lit front wall and columns are framed by areas of deep shadow in the foreground and background, making the illuminated centre of the picture stand out, almost glowing, in contrast.

Without local tone, highlights are not usually visible. If you want a subject to look shiny it's therefore necessary to include more subtleties of tone or at least a strong mid-tone. Keep the overall contrasts high and the brightest highlights very clean and white.

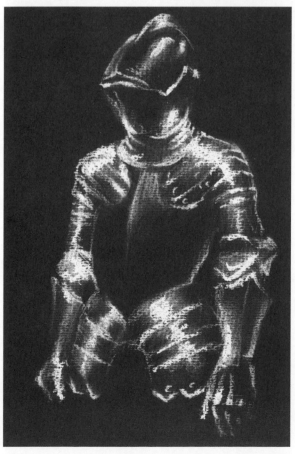

On the other hand, you can draw with nothing but highlights. A toned ground stands as shade and local tone, and every white mark you make immediately appears to shine. Here I drew with a hard white pastel pencil, smudged for reflected light, and a very soft white pastel for the brightest highlights.

DRAMATIC LIGHT

When you can take charge of light in your drawings you have a very powerful tool for creating impact and atmosphere. There's something about light to which we respond on an instinctive level, so you have the viewer on your side already, but it does require a tight control of tonal values to achieve convincing luminous effects.

Even when the aim is to capture luminous effects, the surroundings must be convincingly drawn. I spent some time selecting the framing of this staircase, establishing the general perspective structure and drawing the main shapes and angles.

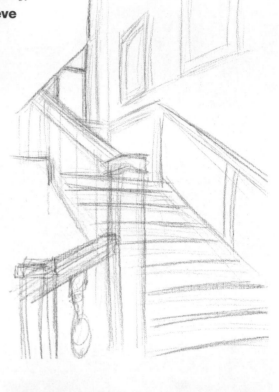

With a thick black marker pen I outlined the most prominent features. Knowing that I would need the full tonal range for this drawing, I used the black freely to infill the areas of deepest shadow. I allowed a few streaks of white to remain in the black areas to give a naturalistic feel and because really solid black can rather overpower a composition.

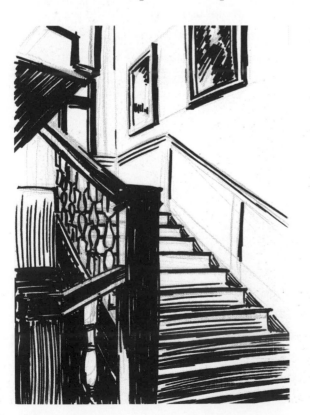

I used a bristle brush, semi-loaded with diluted ink, to paint in the general areas of mid-tone in broad sweeps, making sure that I left the paler areas completely untouched.

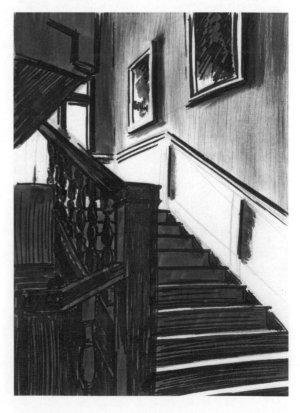

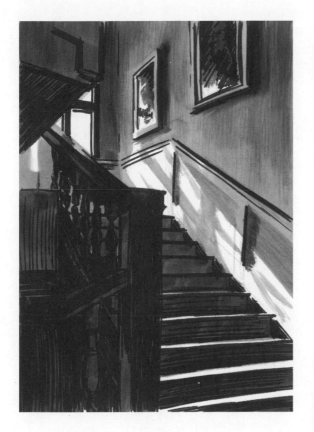

For the next layer of tone I loaded the brush more fully and washed over the whole surface except for the very brightest areas of highlight, deepening the mid-tones, shaping the shafts of shadow and tying together the tones of the picture.

For the final touches, I used a less dilute mix to dry-brush some selected areas of deep shade and then applied a few strokes of white ink for some detailed highlights where necessary.

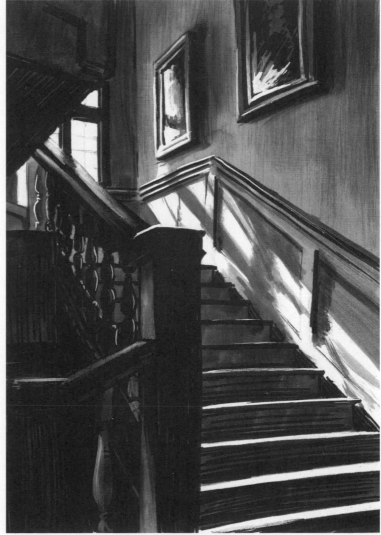

Dramatic light *(continued)*

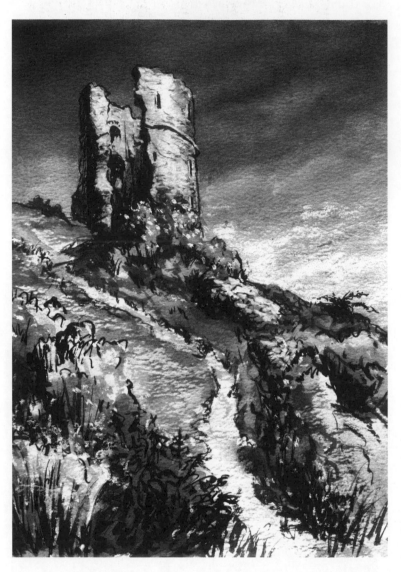

The contrast between the brightly lit subject and dark sky is what gives this scene impact. As well as the striking tonal contrast, our familiarity with such weather conditions and the portent of oncoming storms creates a feeling of foreboding.

Fire is always fascinating, but not always easy to draw. Work at the far ends of your medium's tonal range, keeping the bright areas clean and the darkness as black as possible. With a semi-abstract subject such as flame, it's a good idea to include some items or surroundings of definite and recognizable form to establish a sense of scale.

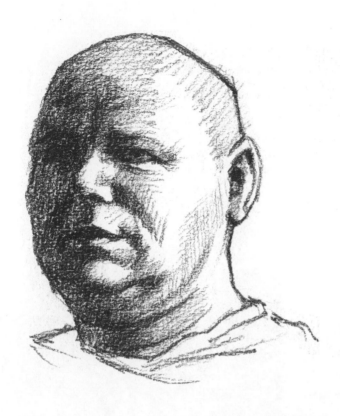

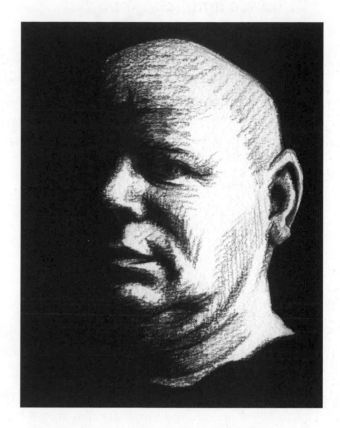

Strong directional lighting can make for imposing portraits, creating deep shadows and modelling the features in stark relief.

Taking things another step further, I added some ink to deepen the shadows and painted a background extending across the darkened face parts. Thus the head seems to emerge out of the darkness and, with most of the head now obscured, an air of mystery is created.

The impact of light is all about managing tonal contrasts – the more darkness you employ, the brighter any highlights will appear in comparison. For example, the sky I observed for this sketch was in reality quite dull grey and the winter sunshine rather weak, but by exaggerating the darks the effect is heightened.

REAR LIGHTING

An effective shortcut to dramatic lighting in your drawings is to select viewpoints that place your subject between you and the light source. This rear-lighting reduces mid-tones to deep shade and silhouette and makes any highlights very crisp and bold.

Although this sketch is quite dark, it speaks of bright sunshine and summer haze. The shadows are as much a feature as the trees that cast them and silhouetted foreground foliage stands out boldly against the patches of sun-bleached ground. Distant details are pale and hazy in the exaggerated aerial perspective one encounters when looking towards the sun.

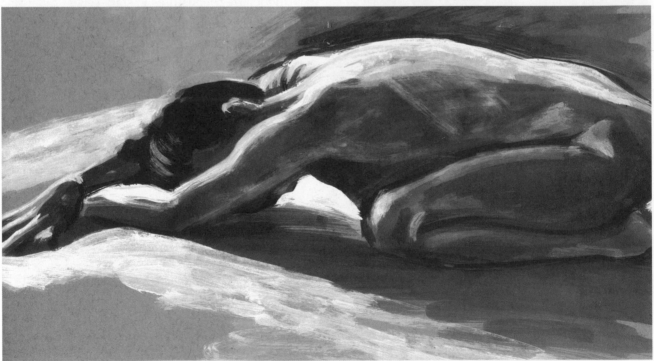

Seen against the diffused light of a window, the highlights reflect brightly off the model's upper surfaces. To enhance the effect I painted dark ink around the top edge.

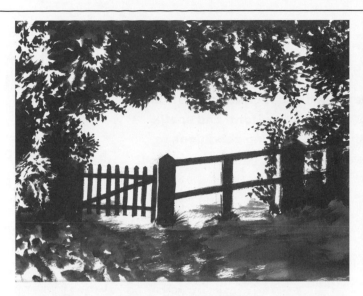

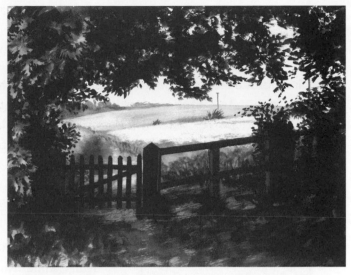

Here the sun was behind me, but the illumination in the scene comes from the brightly lit landscape beyond the gate. With the foreground virtually silhouetted, I could paint all the detail with dark ink (slightly watered down for the ground surface). No pencil guidelines were required, but I went to some effort to make the appropriate marks for the various types of foliage. A few simple washes and details here and there completed what looks like quite a sophisticated scene.

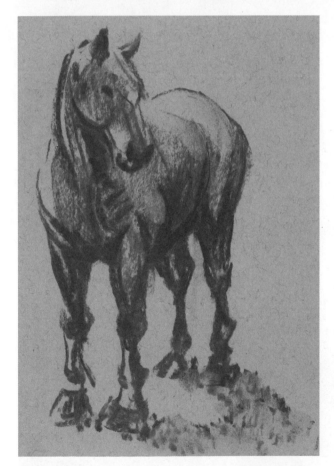

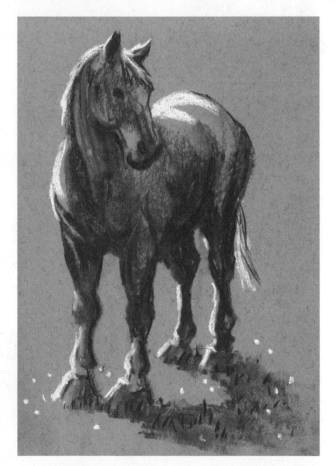

Against the light, the amount of detail visible on this horse was quite minimal. I sketched it quickly with the broad side of short charcoal stick.

Rear lighting produces halo-like effects that can be easily captured with a few strokes of bold white. The horse had moved by this stage, but the highlights were simple enough to reproduce without close reference to the subject.

FLAT LIGHT

In overcast weather, light is diffused across the clouds and radiates down from an indefinite direction. Shadows and highlights are weak, and form and spatial depth are correspondingly flat. These are not the most inspiring conditions to draw in, but they are not without their benefits and uses.

This is the finished version of the demonstration on p.91. Dull lighting was helpful here because it created no deep directional shadows to confuse the technical details and clash with the intended symmetrical rendering.

Similarly, this door was drawn with no direct light, being positioned on the shady side of the building. As an architectural study it benefits from the clear details that strong shadows would interrupt.

The dull light of a snowy day reduced the details of this scene to flat greys against white, allowing me to draw quickly and impressionistically in two shades of grey marker pen while remaining true to the atmosphere of the day.

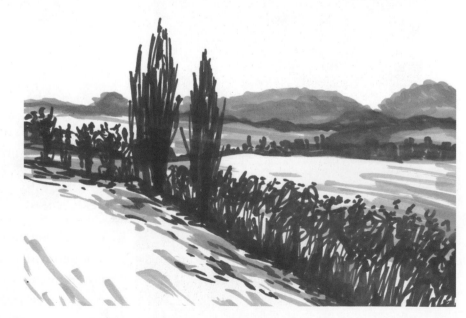

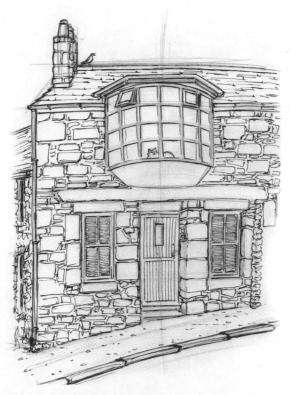

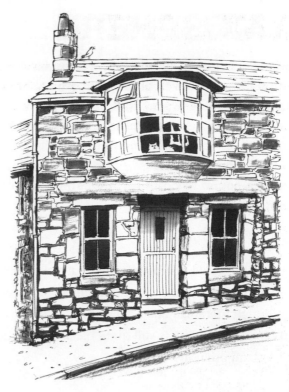

With no clear directional lighting to consider, I inked the outlines of this cottage in a uniform line without much thought or sophistication.

Even on very dull days there will always be some overhead light and corresponding shade, so I started the tonal treatment with a wash that picked out the hollows and undersides as well as the dark local tones.

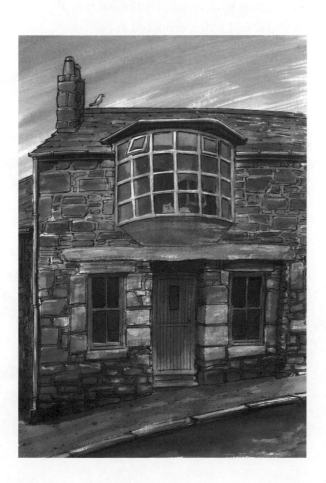

When applying successive washes I left a few paler patches here and there, but generally worked in swift, broad strokes across large areas of the picture. To some extent, I built up the tone for the compositional balance of the picture rather than the natural tones present on the day, yet the finished picture reads as a convincing statement.

ATMOSPHERE

Complex creatures that we are, we can have emotional responses to all sorts of atmospheric conditions. Boldness and light can certainly create a sense of drama, but we can be equally affected by their absence, in the romance of twilight, moonlight and even windswept desolation. Once again, the secret to creating such atmospheres is in controlling the tones.

► A sure-fire way to create a sombre atmosphere is to fill the frame with greys and to keep highlights to a minimum. Even though this small charcoal sketch features a broad tonal range, the feeling is still quite bleak due to the weak shadows and ominous sky.

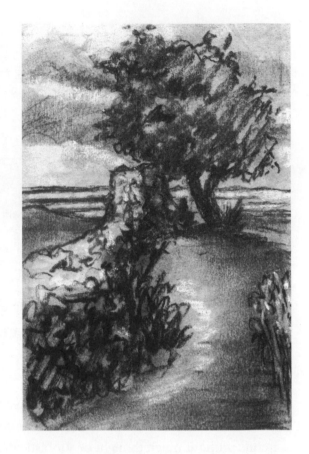

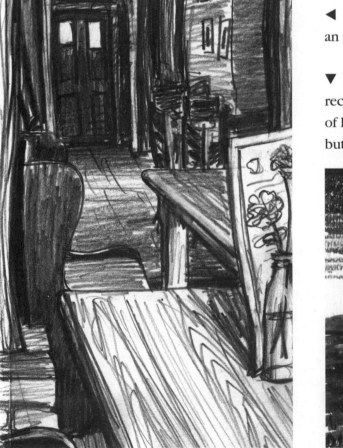

◄ Interior scenes such as this traditional pub also acquire an atmospheric feel when rendered in full tone.

▼ It does not take much to prompt the viewer to recognize certain atmospheric effects. This sketch consists of little more than a few slabs of black and grey felt-tip pen, but it manages to capture an authentic feel of late evening.

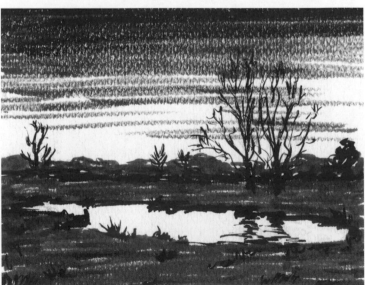

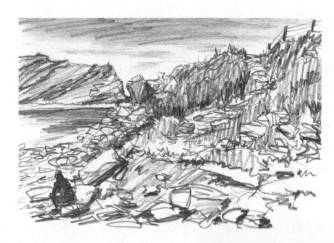

Water-based materials lend themselves particularly well to scenes of bleakness. For this demonstration, I used a watersoluble pencil and scribbled in the main areas of tone and texture. In some ways I like the drawing as it is, but it could be more atmospheric yet.

With a small bristle brush loaded with water – on this occasion, sea water – I worked in sections from the sky forward, dampening the pencil marks, blending them and pushing them around to fill the paper with rich tone, while striving not to obliterate too much of the textural feel.

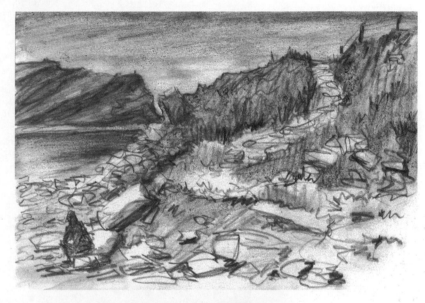

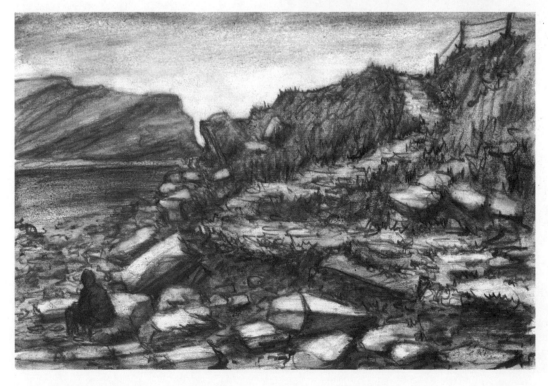

Once the paper was dry I used the pencil again to re-establish the outlines and introduce more tone and detail into the foreground, before working over the drawing with the brush and water again. When it was thoroughly dry, I used an ink eraser to lift out some soft highlights on the rocks and lighten the sky for pictorial depth.

SPATIAL DEPTH

You have seen the effects of aerial perspective (see p.52) and how useful it is to achieve an illusion of deep space in a drawing, and you have also learnt the benefits of reducing tonal variation for the opposite effect. With these skills in your repertoire you can approach some subjects purely in terms of their spatial depth and make it their main characteristic and the subject of the drawing.

106

Standing under the spreading limbs of this ancient tree, I wanted to convey not only the background distance but also a sense of the huge limbs looming overhead and reaching out to the front of the picture. I used pure black ink in combination with grey pastels.

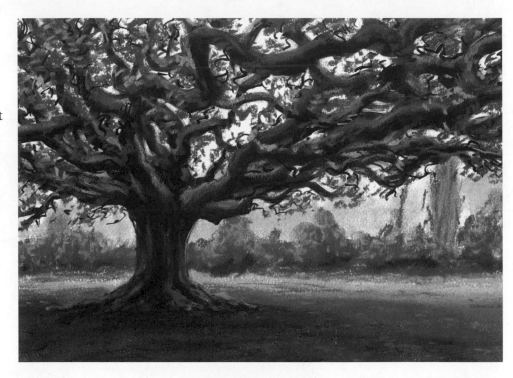

Here I used four or five shades of grey marker to build up the scene from the far distance forward, getting darker in tone as I worked new layers on top of old.

On holiday, I took some photographs of tiddlers some boys had caught in a clear plastic bucket. The murkiness of the water made the visibility extremely shallow, the effect of which was quite eerie. To replicate the effect it was necessary to work in layers. On some lightly textured paper I used the side of a charcoal stick to make swirly, random marks, denser towards the bottom of the page.

I smudged and smeared the charcoal around with a fingertip, just enough to produce a cloudy effect, then added some more charcoal around the bottom edge. Using the tip of the charcoal, I rapidly drew some indistinct fish-like shapes and smudged them to varying degrees.

Referring to my photographs, I drew some more distinct fish forms with charcoal, sharpened with a knife. To lift off highlights and errors, I made a 'tortillon'. This is a small piece of scrap paper rolled into a tight tube, the end of which is fine enough to lift, blend and refine small areas of charcoal or pastel.

I then drew some fine strands of pondweed of various weight and tweaked some details and tones here and there. I sprayed it with fixative and, for a finishing touch, I used a viewfinder (see p.71) to select a suitably balanced composition before framing off the edges with a window mount.

SURFACE

An object's surface can inspire artists to consider such wide-ranging concepts as pattern, tone, shine and texture, and we have seen how each of these may be rendered on the page. Indeed, surface is so intrinsic to many subjects that it's hard to draw them without reference to it. Consequently, making surface a special feature of a drawing often requires very clear intentions and working methods.

108

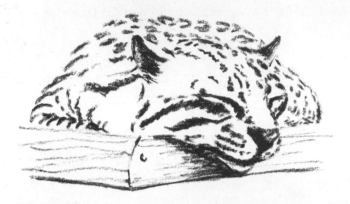

Here I concentrated on surface pattern alone, with no outline and almost no hint of shade – but in order to place the markings and features convincingly I first had to draw the ocelot in a conventional manner and then erase the outlines.

There's barely a mark here that is not aimed at describing the feel of the turkey's wattles, its eye and beak being almost hidden within the texture. There's no need to minutely observe every bump and hollow of such a texture as long as you can convey its essential character in the kinds of marks you make.

The rear lighting here reduced the scene to a kind of pattern, enhanced by the formal view and layered composition. Thus a subject of some depth is flattened, allowing the pure textural silhouettes to be the subject of the picture and the surface of the paper to become an important element in the reading of the drawing.

In contrast, this peculiarly clipped
tree form is all about textural depth.
I used the stiff ends of a bristle brush
to stipple the ink for the appropriate
texture and kept the background
details intentionally flat and featureless.

Built of heavy blocks and tiles and
surrounded by various plants and surfaces,
this house obviously lent itself to a
particular approach in the drawing. Even
though the drawing bears all the elements
of perspective, shade and so on, it still
manages to come across as a textural study
by dint of the busyness of every surface
and the range of marks employed.

Unlike the other examples
here, this sketch of a mirrored
surface (the lid of a waiting-
room bin) provides no texture
of its own. Being curved,
however, it makes its presence
felt in the distorted perspective
of its reflection.

Surface *(continued)*

For heavily and variously textured subjects it can be tricky to keep the distinctions between the elements clear and the drawing readable. To achieve this in a drawing of a densely foliated garden, I worked in layers and also varied the materials to make the depth of the composition clear.

After making rough pencil guidelines I drew in the cottage with a very fine-tipped drawing pen (0.1mm), working mostly in horizontal and vertical strokes and trying to avoid making it too detailed and fussy.

Working towards the foreground, I used successively broader pens in appropriately larger marks, giving each different plant its own kind of mark. Don't be afraid to draw over the top of previous layers; the overlapping is a great device for enforcing spatial depth.

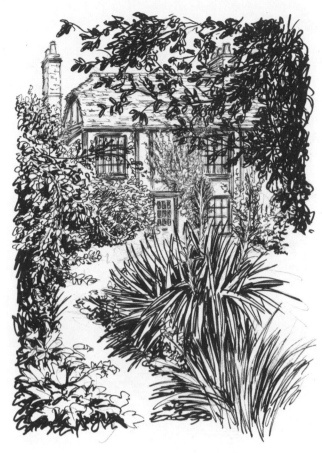

Next, to really push the depth and bring out the individual forms, I used some heavy black shading, again working in marks that were sympathetic to the plants they aimed to depict.

I filled in the gaps with the appropriate pens, being careful not to overwork them. It's important to allow some space for the eye to move through the scene and when the scene is as busy as this, such little moments of relative calm are especially welcome. To finish I erased all the pencil marks and framed off the edges. The tight framing with details running off every edge helps to make scene look really full to overflowing.

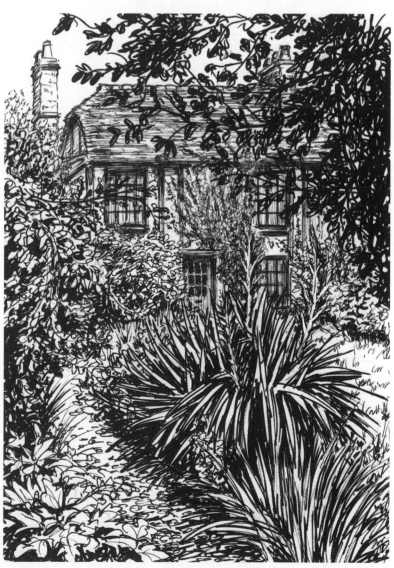

REAL LIFE

In our lives we tend to favour tidiness and cleanliness, yet those virtues in drawing can come across as stiff and sterile. Evidence of wear and dirt lends drawings a sense of truth and honesty about a subject, making the artist appear more competent and sophisticated. It also shows something of life going on in the real world, which is far more visually appealing than a pristine, lifeless environment.

These are two sketches of the same pig, a noble beast but hardly a delicate specimen. In one I aimed to emphasize the coarse hair and inelegant attitude, while in the other I concentrated on the mud staining its legs and snout. Both are scruffy sketches that say something about the animal's nature.

The drawing language you use goes a long way towards defining the level of scruffiness you want to achieve. Here's my wife, not looking her best admittedly, her unkempt work clothes and general dishevelment accentuated by broken outlines, random shading and smudges.

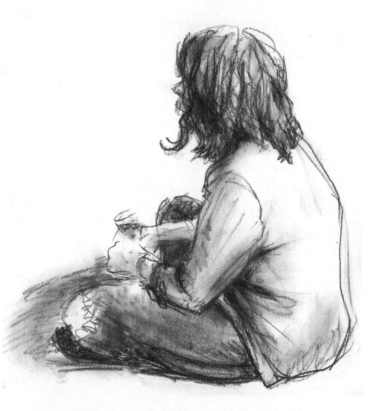

Once you accept dirty or untidy subjects as valid, there's a whole new world of subjects open to you and you need not look far for inspiration. This sketch has been smudged and stained by its opposite page in a sketchbook, but the extra scruffy marks only add to the effect.

With its capacity for line, shading, brushmarks and wash, watersoluble pencil can be used for effortlessly scruffy effect. The more slap-dash the fashion in which you use it, the more effective the results. I added the graffiti over the top with a white chinagraph pencil.

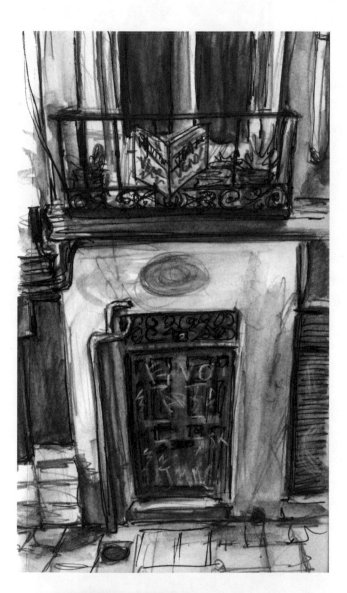

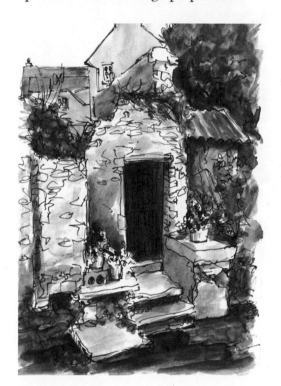

Ramshackle levels and weed-infested, broken surfaces gave this old garden gate a feel of clutter and disarray. I used the pen in a semi-continuous line manner (see pp.74–5) and applied a couple of watercolour washes in imprecise motions that strayed beyond outlines.

A COMPLEX SCENE

As we have seen, working quickly and freely brings the necessary feel to subjects that aren't clean and tidy. It also helps to give liveliness and freshness to the drawings. More complex scenes featuring multiple elements require a more carefully considered drawing approach, but if broken into logical steps even very cluttered scenes may be drawn very broadly without sacrificing readability.

I used a broad, soft brush and quite a rich solution of ink. Having selected a suitable framing with a viewfinder, I started with the main subject, the deer, drawing only the broad masses of deep tone in broad slabs.

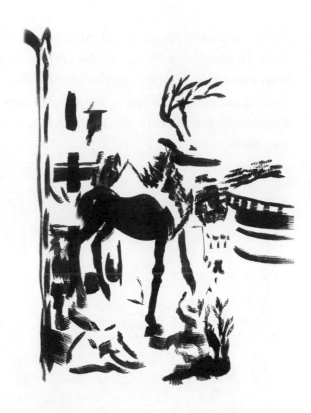

With a thinner mix, I worked on all the mid-tones. Although it looks quite random, I was looking out for any masses of highlight, for which I needed to leave the paper untouched.

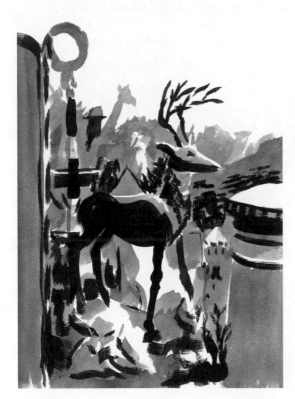

To bring some form to the blocks of tone I switched to a finer brush and undiluted ink and worked on the outlines of the main elements. It became apparent where I had gone astray with my original tone drawing, but I let the outline generally follow the placements and forms of the tone drawing.

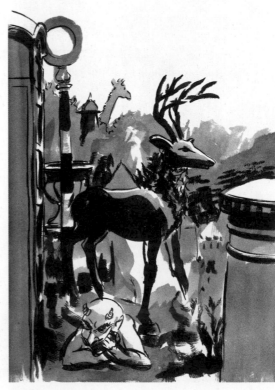

Even though the drawing up to this point may not have been entirely accurate, once the main forms were established the rest of the details could be drawn in to fit within the spaces available. It may be tempting to fill in with random shapes and marks when you do this, but it's always worth taking your cues from observation of the scene.

I reverted to the diluted ink to strengthen some of the tones and to work around some of the infill details, helping to give them form and definition. Then I used white ink for highlights, quickly dabbing and stroking in the same carefree manner as the rest of the drawing.

WEAR AND TEAR

There is something appealing about things that are old and falling apart. A new fence would rarely be considered for anything more than its practical function, but an ancient, tumbledown, overgrown wall fills our hearts with joy. But even when a subject is falling apart it should be clear in the drawing that it is damaged, not just badly built, or, even worse, badly drawn!

With the wobbly lines and rough marks of a battered old brush, my aim here was to convey a feeling of everything sagging and tired. Even so, the sketch was drawn over quite careful perspective guidelines.

The ink does all the work here, but a touch of tone in watercolour adds richness to the subject and a bit of grime. Some white ink provided highlights, but only to restate some drawing features, such as the window bars; I certainly didn't want to make anything look shiny.

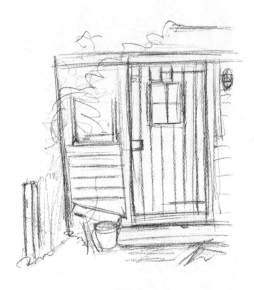

This subject requires a degree of structure to the drawing. In the first stage, I counted, measured, and evenly spaced the planks and panels of the shed's construction, almost as if drawing a new shed.

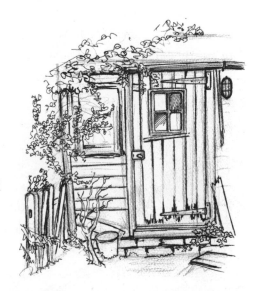

The first things I inked were the parts that overlapped others, such as the hinges, foliage and bucket. Then I loosely sketched in the structural forms and characterful details, occasionally exaggerating wonky angles.

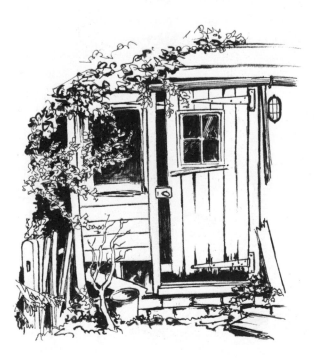

With a touch of ink I filled in the deep hollows to give the subject depth and form. I was careful to avoid making the black too neat and uniform, allowing the brush to run dry in parts. I then erased my pencil lines.

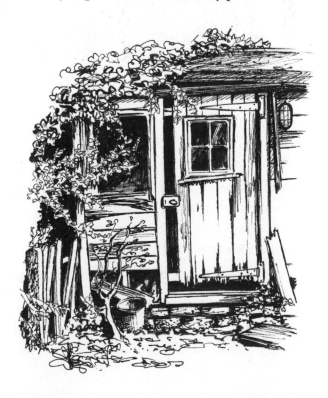

In proceeding to add some textural marks I was cautious about overworking and muddying the picture. It was important to vary the degree of weathering on the surfaces and to leave some parts relatively clean.

Wear and tear *(continued)*

Old and distressed subjects need not be drawn in a rough-and-ready style to look appropriately aged. Despite its obviously crumbled and overgrown state, this arch remains stable and dignified, which I tried to show with sturdy perspective and a clean rendering manner. Strong light and shadow also reinforce its solidity.

Some subjects speak quite eloquently for themselves and demand no special emphasis or treatment. With the ancient axe's warped, split shaft and broken, pitted head, a straightforward drawing of outline and texture is quite sufficient to convey its great age.

Signs of age may be more subtle. To draw the wear and tear on these girl's shoes I selected a formal overhead view, from which the sag of the material is observable as well as the acquired lack of symmetry between the pair. Some stretch marks and a bit of fraying also help with the effect.

People too get more interesting (and easier) to draw as they grow older and their faces become more careworn and characterful. I started this old fellow with a suitably vigorous under-drawing that marked the main crags, wrinkles and high points. I also looked carefully at the sagging lower jaw and neck, which add greatly to a convincing portrayal of age.

I chose an unforgiving black pen for the drawing and worked first on the features of age and character in heavy lines and hatching.

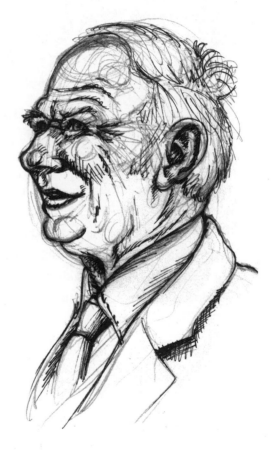

Next I worked up a semi-tonal rendering in swift, jagged motions that follow the directions of wrinkles. I also spent some time on the hair and particularly the rather unruly eyebrows. Tempting though it was to continue shading ever more detail, there comes a point where extra marks add nothing new and actually start to detract from a drawing.

PERSONALITY

With such diversity and subtlety of subject matter in the human face and form, it's no surprise that artists are drawn to the idiosyncracies to be found there. The challenge is always the same – to capture the particular essence of an individual. That essence can usually be contained in a few strokes of a pencil – and no amount of detailed rendering will make up for a failed likeness.

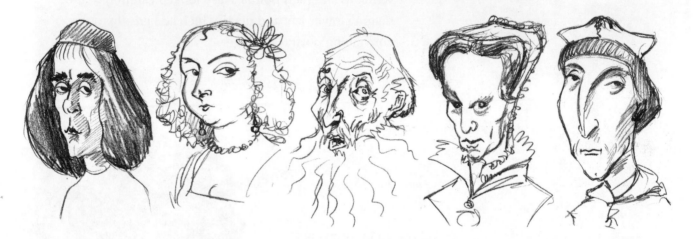

A great way to get to the heart of an individual personality is to practise exaggerating the most noticable features of the face and amplifying the expressions. Caricature is a tricky skill to master, but it shouldn't be painstaking. Here are a few of the dozens of quick caricatures I sketched over an hour or two in an art museum, spending no more than two or three minutes on each. In your own sketches, look at face shape, notable features, expressions and attitudes and allow yourself to distort proportions quite freely.

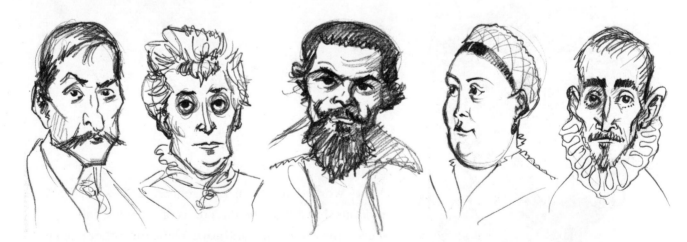

After some practice at caricaturing, you should find that you develop a feel for the individual characteristics of a face. I drew these examples immediately after the previous caricatures, seeking this time to merely respond to the subjects rather than impose my will upon them. The results are mildly caricatured but quite accurate likenesses, yet without the effort of careful observation and measuring.

This is a tiny selection from the many quick character sketches I have done over the years in waiting rooms, cafés and buses. When people are unaware that they are being observed you see them at their most natural, often quite bedraggled or melancholy. Draw swiftly with the aim of capturing the personality behind the blank expressions.

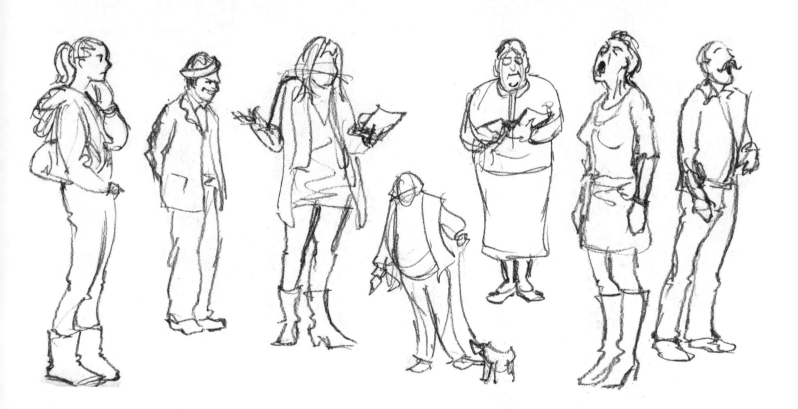

There is much more to personality than people's faces. Body shapes and proportions, clothing, hairstyles, age, posture, gesture, and many other factors contribute to the mix of an individual character. Drawing family and friends is great for getting started but to really sharpen your skills, get out among the public and sketch all sorts of people as boldly as you can. It is by repetition that you will quickly gain familiarity with all sorts of body types and the telling subtleties of body language.

Personality *(continued)*

Street performers make great subjects for character drawings.
They tend to be flamboyant in looks and actions and are quite
comfortable with being openly observed. They will also remain
in situ for lengths of time, allowing multiple studies and sketches,
such as this small selection.

Having amassed a number of sketches, I had enough material
to develop them into a more finished piece in the comfort
of my studio. I decided to base the drawing around the
musicians' stout builds and the way they moved with the
music. I started with broad masses upon which I could add
the details drawn from my sketches.

I kept the pencil work generally quite loose and unfussy, with just enough detail to allow for a carefree approach to the inking. I used a broad brush with a fine tip to transcribe the features in bold, flowing marks and referred to my sketches and some photographs of other musicians in order to place the hands convincingly on the instruments.

With the inking complete and the guidelines erased I could take stock of the drawing and decide how to proceed.

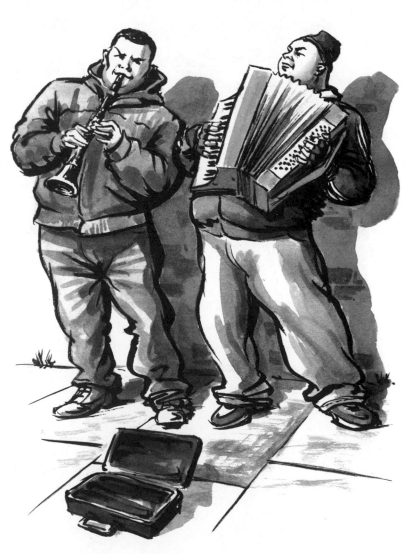

A couple of watercolour washes, applied with the same looseness as the ink line, gave the figures bulk and added to their slightly dishevelled appearance. To complete the scene, I added some detail to the floor plane and devised a simple background to give the figures a sense of a setting.

WHIMSY

Drawings don't need to be serious and intellectual to be worthwhile – indeed, there's much to be said for a bit of playfulness and charm. Such lightness may come naturally out of your choice of subject matter or it may require a degree of contrivance, but either way, the important thing is to recognize that there's nothing wrong with raising a smile.

124

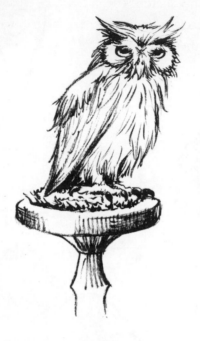

We love to read human emotions into the expressions of animals, a concept known as anthropomorphism. I came across these sanctuary birds on a very wet day and strove to convey their state of bedragglement and ennui. It may be tempting to stray towards cartoon exaggerations, but I prefer to aim for more naturalistic features and expressions.

This is my original version of the drawing on p.58 to illustrate the artist's power to play with the viewer's reading of a subject. By the simple decision to omit or include the pigeon you can present an image of either regal dignity or punctured pomposity.

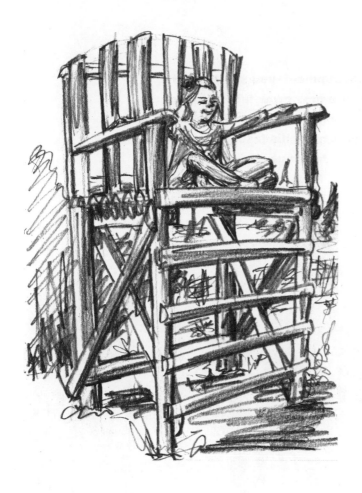

Some subjects are just fun in their own right, such as these sketches, both of which derive some playfulness from contrasts of scale. A pocket sketchbook allows you to take advantage of unusual opportunities such as these when you come across them.

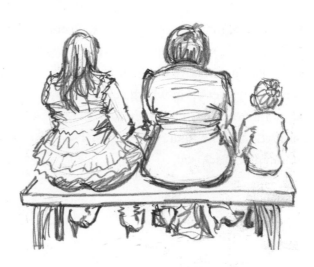

The subject of this drawing is much the same as the previous example: a small child in oversized furniture. But this one invites a more emotional response, because this is a hospital bed of normal proportions, exaggerated in expanse only by the close-up viewpoint, which makes the child seem all more tiny and helpless.

NARRATIVE

As soon as you place two or more figures in an environment, you stimulate the viewer's curiosity. We humans have an in-built desire to know what's going on between characters and to seek a satisfactory reading of an image, and it's remarkably easy to set up simple interactions that play to this fascination. And so we move into the realm of telling stories with our drawings, giving them a life beyond the marks on the paper.

This is a straight copy of a garden sculpture, so the sculptor (Francisco Pintado, 1887–1980) must take the creative credit. It's a good example of a set-up in which very little is happening, but there's just enough in the interaction of the figures to suggest a secret about to be disclosed.

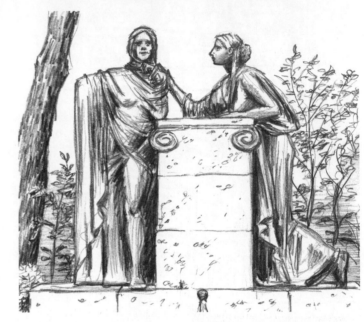

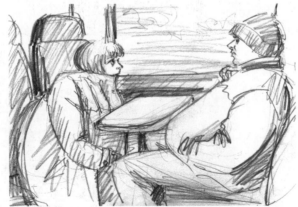

The narrative in this sketch of train passengers is suggested by the body language, the woman leaning forward with an edgy expresson, the man more laid-back and uninvolved. Odd little moments like this are playing out all around us all the time – all it takes is for the artist to set them down on paper.

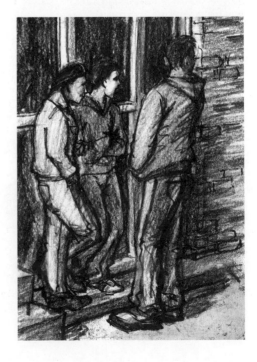

A group of youths huddling on a street corner is a subject likely to stir a response in many viewers and all the more so if the drawings capture the gloom and grime of the setting. However, what intrigues here is the unseen focus of attention beyond the frame of the picture.

I livened up a boring lecture by sketching the speaker against his old master backdrop and introducing a knife into the mix. That the two elements are of similar scale and drawn in a similar manner creates a potential for interaction. In drawing you can have endless amusement by combining elements in creative juxtaposition, changing the meaning or perception of each.

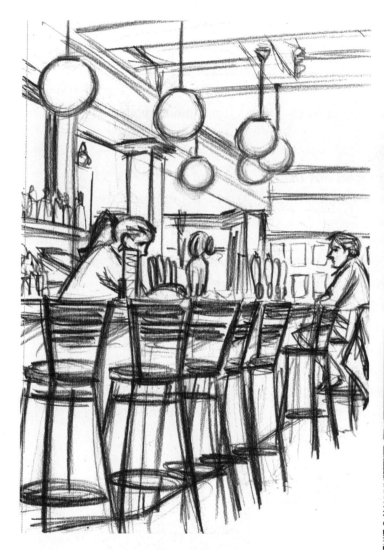

The very fact that there's no obvious interaction between the inhabitants of this bar poses some questions of its own. A scene like this sets up expectations but the drawing is vague enough to provide few answers, compelling the viewer to make assumptions about the time of day, the mood, the relationship between the figures, their backgrounds and so on.

There are no figures to create a narrative in this scene, yet the disturbed furniture tells its own story and it's hard to avoid a sinister reading. And then, in the mirror, is that a person reflected? And if so, what is their involvement?

aerial perspective *52-3*

angles *21, 30-1*

atmosphere *103-5*

bright light *94-5*

brush drawing *58-61, 76, 77*

brushes *54, 58-9*

caricature *120*

cast shadow *47*

Cézanne, Paul *46*

charcoal *53, 74, 79, 107*

charcoal drawing *50-1*

complex scenes *114-15*

composition *68-71, 126-7*

continuous line *74-5, 113*

crayon *49, 89*

crayon drawing *77*

curves in perspective *37, 39*

depth *52-3, 106-7*

detail *11, 13, 17*

directional lighting *99*

dramatic light *96-9*

dry brushing *59, 77*

elegance *88-9*

equipment *10*

erasers *10, 13*

felt-tip pens *57*

figure drawing *22-4, 42, 64-5, 87*

fixative spray *51*

flat light *102-3*

form *11, 28-9, 31, 86-7*

format *16*

framing *68-9, 92, 96, 107*

guidelines *12-14, 18-27*

hatching *48-9*

heads *25-7*

highlights *47, 57, 64-5, 77, 95, 97, 100-1*

high viewpoint *27, 41*

horizon *33*

ink drawing *56, 58-9, 76, 77*

landscape format *16*

light *46-7, 49, 73, 94-5, 96-9, 100-1, 102-3*

lines *42-3, 74-5*

local tone *46-7, 73, 95*

low viewpoint *27, 40, 85*

mark making *28-9, 42-53, 76-7, 82, 84, 108-111, 112-3, 116-9*

marker pen drawing *62-3*

mass *11, 12-15*

materials *10*

measuring proportions *18-20*

multiple masses *14-15*

narrative *126-7*

observational skills *8-9*

one-point perspective *32*

page use *16-17*

paper *10, 16-17, 54*

pastel drawing *64-5, 76*

pencil sharpeners *10*

pencils *10*

pens *10, 48,-9, 56, 110-1*

personality *120-3*

perspective *32-41, 52-3*

portrait format *16*

portraits *25-27, 50-1, 119-123*

proportions *18-20, 22, 25, 31*

quick drawing *80-1*

rear lighting *100-1*

receding angles *30-1*

reflected light *47*

reflections *36*

restricted tone *72-3*

scale *78-9*

selection *68-9*

shade *46-7, 55, 94, 96-9*

shading *46-9*

shape *11, 12*

shapes *37-9, 46-7, 92*

sight-sizing *18-19*

size *16*

sketchbooks *17, 83*

sketching *82-5, 121, 125*

spatial depth *106-7*

surface *108-11*

symmetry *90-1*

texture *44-5, 47-9, 55, 108-111*

three-point perspective *40-1*

three-quarter views *26-7*

tone *46-7, 55, 57, 72-3*

toned paper *64-5, 95, 100-1*

two-point perspective *34-5*

vanishing point *32-34, 37, 40, 63,*

variations of line *42-3*

viewfinder *71*

viewpoints *26-7, 28*

wash drawing *54-7, 60-1, 65, 103, 114-5*

watercolour *54, 76, 116*

watersoluble materials *57, 105*

wear and tear *116-18*

whimsy *124-5*